ART

FOR BEGINNERS®

DANI CAVALLARO

ILLUSTRATED BY CARLINE VAGO-HUGHES

Writers and Readers

Writers and Readers Publishing, Inc.
PO Box 461, Village Station
New York, NY 10014
e-mail:sales@forbeginners.com

Writers and Readers Limited
PO Box 29522
London N1 8FB
e-mail: begin@writersandreaders.com

Contents

This book is dedicated to our fathers,
with love.

Reading Images

Our place in the world is determined by how we see it. Seeing the world as conscious beings means understanding how images are constructed in particular ways and at particular times.

The Constructed Image

In making images, we also make ourselves. Images enable us to interact with our environment and to structure it according to a variety of ideas, feelings, fantasies and fears. Images contribute vitally to our sense of who we are and to our daily negotiations with the world. Making images can also be a way of contriving a sense of personal power in menacing or hostile surroundings.

FOR EXAMPLE, MANY HAVE ARGUED THAT PREHISTORIC PEOPLE DIDN'T PAINT PICTURES OF ANIMALS OUT OF A DESIRE TO DECORATE THEIR CAVES, BUT RATHER IN ORDER TO ASSERT, SYMBOLICALLY, THEIR POWER OVER THEIR PREY.

We are surrounded by images all the time. They often have a strong impact on our minds and bodies without us knowing why. We merely take them for granted. A way of becoming more critical of the images with which we live is comprehending how they have been *put together* to achieve specific effects. After all, any image has been constructed by someone and for someone.

1

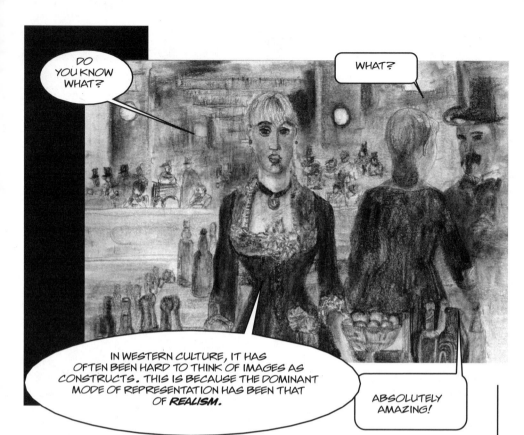

Realist techniques would have us think that images mirror reality, that they offer a keyhole view on a solid world, there for everyone to share. Realism encourages us to neglect the artificial constitution of images and to take them as *natural*.

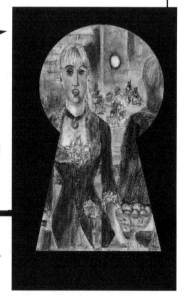

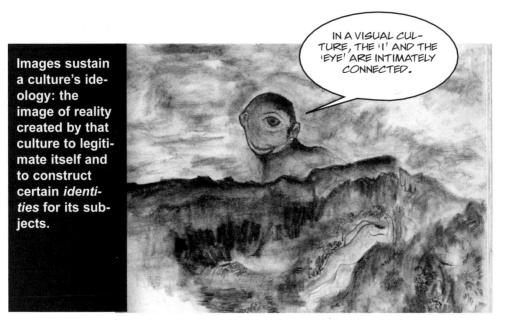

Images sustain a culture's ideology: the image of reality created by that culture to legitimate itself and to construct certain *identities* for its subjects.

For example, when Realism denies that images are constructed, it aims at passing itself off as an objective representation of reality in the service of ideological stability. It tells us that reality is unchanging. To deny that something was made is to deny that it could ever be *un*made. But once we see images as cultural fabrications, we begin to realize that if an image can be assembled, it can also be *dis*assembled.

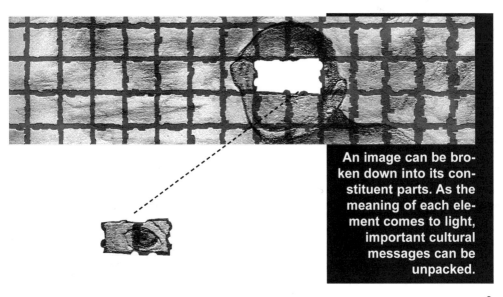

3

The visual representations we encounter every day are not 'slices of life', cut out of a stable reality ordained by the gods. They are *artificial organizations of meaning*.

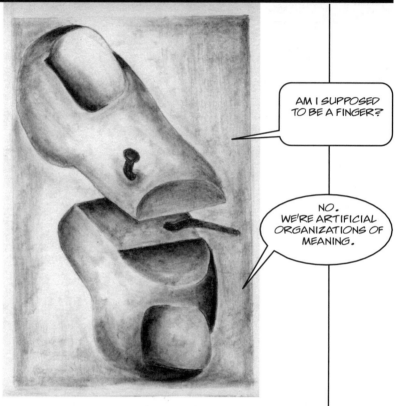

Art, literature and the human mind itself do not reflect reality but rather *represent* it according to conscious, semi-conscious and unconscious codes and conventions. This is demonstrated by the fact that not all cultures embrace Realism as their dominant mode of representation.

Many representational styles are deliberately unrealistic, stylized or abstract.

We are all born into certain systems of seeing and representing the world.

WHAT WE SEE IS CAUGHT UP IN A NETWORK THAT COMES TO US FROM THE OUTSIDE, THAT SAW THE WORLD WELL BEFORE ANY INDIVIDUAL PERSON DID AND WILL GO ON SEEING IT WELL AFTER THAT PERSON HAS CEASED TO BE.

Vision is always a *socialized* phenomenon. What we see is not just light, shapes and colours but forms: the forms which our culture has defined as *visible*.

There are many ways of seeing (or '**scopic regimes**') and these depend only to a limited extent on our physiological capacity for visual perception.

Rather, they have to do with how we are *able*, *allowed* or *made* to see. They also depend on what we 'make' of what we see and on the degree to which we can grasp the *hidden* elements lurking inside the visible things.

The 'Speaking' Image

When we look at a visual image, we often don't know what we are seeing. We tend to take in the overall effect without paying much attention to the image's details. Of course the over-all effect plays a vital part in eliciting sensations of pleasure or displeasure. But images *speak* subtly, through the interweaving of many minute elements. Unless we are 'experts' or 'professionals', we often let this complex language pass us by.

There is a simple reason for this unre-flective attitude to images. When we are faced with a picture we assume we can possess it in a single glance. Everything is there at once for us to see. A picture doesn't require us to plod sequentially through its signs in the way a written text does. But this doesn't mean that pictures are 'easy' to read. We wouldn't dream of grasp-ing a whole novel by just looking at it as an object. By the same token we should not presume that a visual image discloses its messages all at once. If looked at carefully and with enough curiosity, pictures too turn out to contain all sorts of plots, narratives and characters.

At times, our eyes are 'guided', through various techniques and tricks of the trade, to read a picture's stories in particular ways. At others, all we are given is clues and it's pretty much up to us to string them together into a story.

There is no magical key to the understanding of visual art. There is no way of ascertaining why certain images affect us and others leave us cold. And there is no final criterion for establishing when or why a picture becomes a work of art. The continuing appeal of so-called 'masterpieces' may have little to do with their intrinsic features. We probably wouldn't even think of them as masterpieces if we hadn't been *taught* to do so.

I LOVE BEING A MASTERPIECE.

THAT'S REALLY ENIGMATIC!

DOES THIS MEAN WE ONLY SEE AND APPRECIATE WHAT WE ARE PROGRAMMED TO SEE?

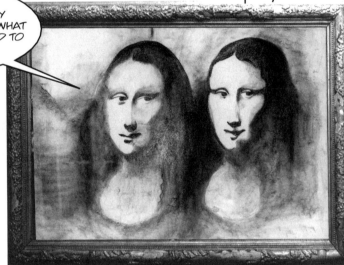

If this is the case, then deepening our understanding of what we see is not just a way of learning more about art. It is also a means of understanding how we are swayed and conditioned by all sorts of images.

EXPLORING ART'S LAN-GUAGE MAY MAKE US MORE ALERT TO THE AGENDAS OF ALL VISU-AL SYSTEMS OF SIGNIFICATION, INCLUDING ADVERTISING AND THE MEDIA.

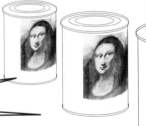

The tools used to study art can also be applied to other forms of visual representation.

Patterns of Illusion

Gestalt psychology argues that we don't perceive things as isolated objects but rather as parts of a pattern and in relation to their context. (Gestalt means 'configuration'.) Even if an object's shape and size remain constant, they will appear different in different configurations or patterns.

The appearance of an object can be changed dramatically by changing its context.

Two of the most important concepts in this theory are those of **figure** and **ground**. 'Figure' refers to the objects we see and 'ground' to the backdrop against which we see them. Figure has a recognizable shape and clear boundaries; ground has no determinate outline and stretches indefinitely behind the figure. Individual items look different in different contexts, and even within a single image they will be interpreted differently, according to whether they are seen as figure or ground. Indeed there are times when the same parts of a picture can be perceived *either* as figure *or* as ground.

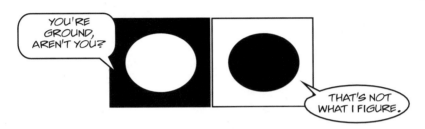

When we see them as figure, we single them out as separate objects against a continuous ground. When we see them as ground, they don't appear interrupted but seem to continue behind the figure. In the 'wheel' shown below, we have an example of *figure-ground reversal* suggested by the psychologist **E.J.Rubin** (1886-1951).

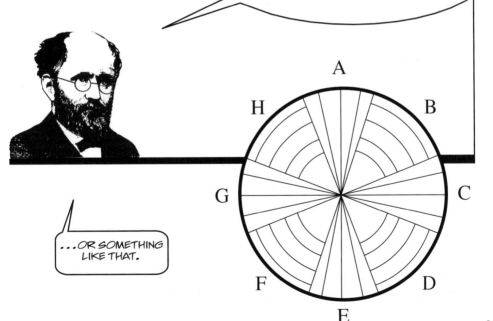

Ambiguous images in which figure and ground alternate show that the viewer is active and not passive in the process of perception. Interpretation involves a 'dialogue' between the image and the beholder. Consider the famous duck-rabbit riddle:

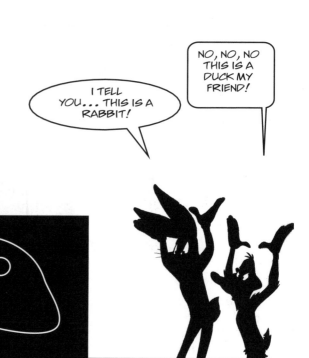

If I say that this image represents a duck looking left, I am neither more 'right' nor more 'wrong' than a person saying that it represents a rabbit looking right. Both of us are partly right and partly wrong. On the one hand, *both* the duck *and* the rabbit are 'there'. On the other, *neither* of them is 'there'. What we are perceiving is not reality but 'effects' of reality. No one reading is more correct than any other. And so, in a sense, all readings are *illusions*.

The ways in which we perceive things cannot be wholly accounted for by brain processes and by physiology. They follow the impulse to organize what we see into a pattern. It's not always clear why a pattern is formed in preference to other available configurations. But Gestalt psychology believes that there are certain 'laws' which determine what we prefer to see as figure and what as ground. One of the most important laws is that of *enclosedness*: we tend to perceive enclosed regions as figure.

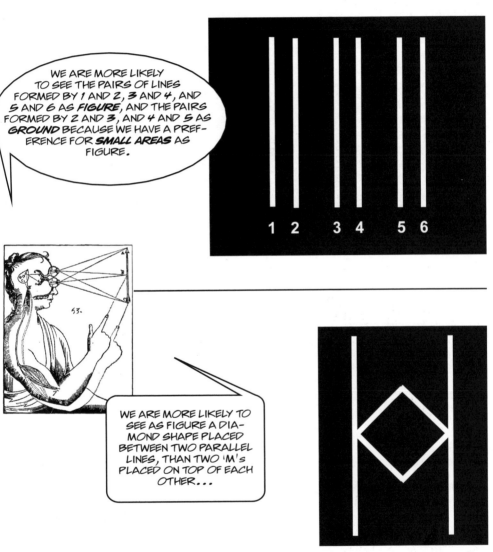

WE ARE MORE LIKELY TO SEE THE PAIRS OF LINES FORMED BY 1 AND 2, 3 AND 4, AND 5 AND 6 AS *FIGURE*, AND THE PAIRS FORMED BY 2 AND 3, AND 4 AND 5 AS *GROUND* BECAUSE WE HAVE A PREFERENCE FOR *SMALL AREAS* AS FIGURE.

1 2 3 4 5 6

53.

WE ARE MORE LIKELY TO SEE AS FIGURE A DIAMOND SHAPE PLACED BETWEEN TWO PARALLEL LINES, THAN TWO 'M's PLACED ON TOP OF EACH OTHER...

...because...

...we tend to perceive *bounded* regions as figure.

Images do not have stable identities. They only gain meaning as a result of our continuous engagement with our surroundings. Perception and understanding are gradual processes. We work on the basis of 'hypotheses', which we set up and which further experience will confirm or disprove.

All hypotheses are provisional and relative because they depend on our ability to separate one thing from another and, as we have just seen, this is not always possible.

The meanings of images shift constantly as our interpretations of them do. All sorts of factors influence these fluctuations. For example, **perspective** and **distance** modify our vision in radical ways: a car viewed from a plane looks like an ant, but an ant floating in a glass of wine looks big enough to bother us.

WE MUST ALSO CONSIDER THE EFFECTS OF *DIS-PLACEMENT:* WHEN WE ISOLATE IMAGES OR DETAILS OF IMAGES FROM THEIR CONTEXTS THEY LOOK QUITE DIFFERENT AND TAKE ON NEW MEANINGS.

A **Leonardo** or **Waterhouse** female face taken out of the original painting and inserted into an ad is no longer a mythological or allegorical figure but just a pretty girl! In all cases, the dividing-line between 'illusion' and 'reality' is blurred. There is a sense in which everything we see is an illusion because we always see according to pre-established codes and conventions.

I'M NOT JUST A PRETTY FACE!

12

All the senses are affected by illusions and all perceptions are subject to errors. But 'visual' illusions are the best known, largely because art uses them deliberately to achieve a wide range of effects. Just think of **perspective, anamorphosis, foreshortening**, etc. Illusions can be produced through very simple techniques, but simplicity doesn't make them any less powerful.

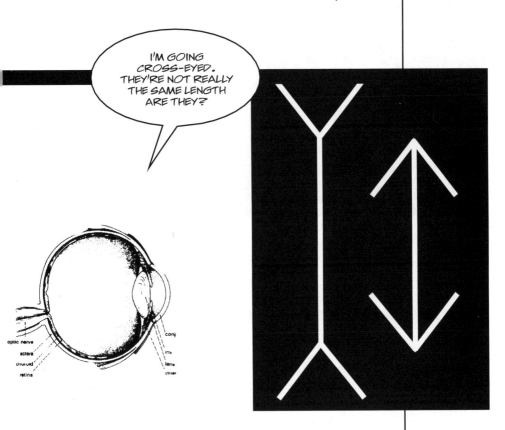

The shape on the left 'looks' longer than that on the right. In one case, the diagonal lines placed at the top and bottom of the vertical line *expand* it; in the other, they *shrink* it. Yet the two vertical lines are exactly the same length.

Not all illusions are of the same type. There are *physiological* ones: for instance, 'after-images', or the images we see immediately after the eye has been stimulated by bright light. And there are *cognitive* ones. These are more difficult to explain.

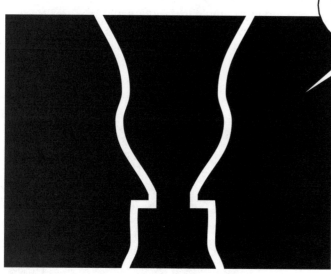

WE'RE EITHER IN DEEP HEAD-TO-HEAD CON-VERSATION. OR I'M A CUP. HOW SURREAL!

Sometimes they are produced by *ambiguity*. An obvious example is the case of figure-ground reversal explored earlier.

MMM.. THAT PURPLE SMELLS DELICIOUS!

Another example is **synaesthesia**, a confusion between different senses which makes us feel we can taste a smell, see a sound, hear an image, so that we set up all sorts of correspondences among disparate sensations. At other times, cognitive illusions are a matter of *distortion*. Perspective, for example, creates the illusion of depth on a two-dimensional surface by its handling of converging lines.

Does this mean we're seeing ghosts? To take another example: are we 'hallucinating' when we see faces in carpets, tiles, flames, glass, or clouds? Strictly speaking, hallucination is a perception of something that isn't there but looks (and feels) as solid and vivid as if it were. But it doesn't really matter whether what we see is truly 'there' because *nothing* is unquestionably 'there'. In a sense, anything exists as long as somebody sees it!

The visual arts alert us to the fact that the world we see is never the world as it is.

What is Art?

There is no universal definition of 'art'. Art is not easily described by the materials it uses or by what is done to those materials.

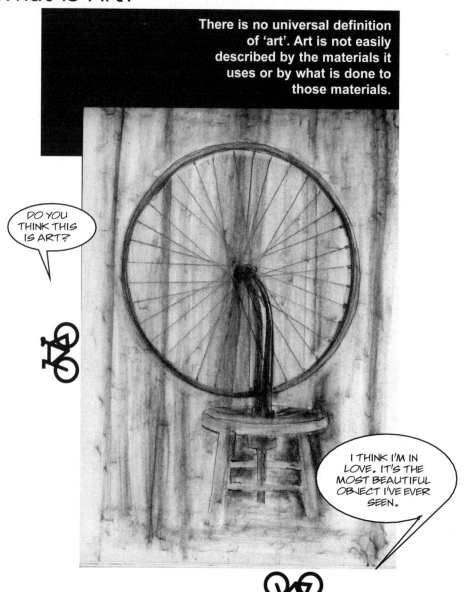

An artwork can be thought of as a physical object or as a formal pattern, but either way it is hard to establish whether there is anything 'unique' about it.

The Expressive Urge

It's difficult to explain on what grounds radically different styles and techniques can all be referred to as art. What is it that enables us to group together as 'art' prehistoric, Renaissance and abstract paintings, for example? What does the stylized image of a bison on the wall of a cave share with Michelangelo's *Sistine Chapel* or Mondrian's geometrical compositions?

Figures of animals painted on cave walls by prehistoric artists (c. 2,000 BC) recorded their hunting exploits and their desire to encode in magical form their relationship with the natural world. **Michelangelo** (1475-1564) aimed to express a cosmic vision through mighty human forms which embodied spiritual values yet were filled with earthly solidity. **Mondrian** (1872-1944) wanted to convey a sense of formal harmony through abstract forms, such as red, yellow and blue squares bounded by straight black lines. On the surface, these works have very little in common.

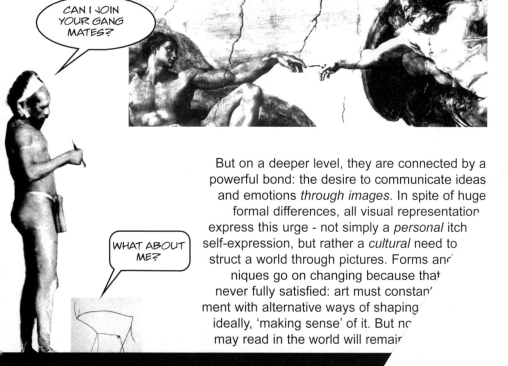

CAN I JOIN YOUR GANG MATES?

WHAT ABOUT ME?

But on a deeper level, they are connected by a powerful bond: the desire to communicate ideas and emotions *through images*. In spite of huge formal differences, all visual representation express this urge - not simply a *personal* itch self-expression, but rather a *cultural* need to struct a world through pictures. Forms and niques go on changing because that never fully satisfied: art must constan' ment with alternative ways of shaping ideally, 'making sense' of it. But nc may read in the world will remair

There are many possible answers to the question 'what is art?'.
Let's look at some of the most popular ones.

Some people think that art means *high* culture in opposition to *mass* culture: art is the product of the 'Great Masters' and should not be confused with everyday commodities.

THE PROBLEM WITH THIS APPROACH IS THAT IT IS INCREASINGLY DIFFICULT TO SUSTAIN THE SEPARATION BETWEEN 'HIGH' AND 'MASS' CULTURE IN SOCIETIES WHERE *EVERYTHING* CAN BE ENDLESSLY REPRODUCED AND RECYCLED.

Others believe that art is the world of *fiction* or invention in opposition to the real world of *facts*. This approach is also problematic: as we saw in the preceding section, *everything* (not just the artwork) is to some extent a 'representation'.

Although art itself is not a universal concept, the expressive drive can be found in most cultures. In assessing how the urge to represent manifests itself over time, we should not think in *evolutionary* terms: stylistic changes don't show that art 'improves' through the centuries but rather that *ways of perceiving reality* vary from culture to culture.

For example, an Egyptian artwork is far more styl-ized and non-naturalistic than a Greek work from the Classical period. But this doesn't mean that the Egyptian artist was 'naive' and the Greek one 'clever'.

YOU JUST DON'T UNDER-STAND ME.

WE DON'T SEE THINGS THE SAME WAY, THAT'S ALL.

The difference is one of perception and purpose. The Greek artist wanted to represent a material reality in natu-ralistic ways; the Egyptian artist was concerned with capturing universally representative aspects of the world in stylized ways. Inquiring about the nat-uralism of an Egyptian artwork would be just about as relevant as inquiring about the state of mind of the green man in the traffic light.

What we call 'art' can only be understood in relation to specific styles. And style grows out of a culture's desire to give shape to the world in particular ways.

Ancient Egyptian art, for example, is based on the idea that images should display the most characteristic features of people and objects. It's hardly likely that Egyptian artists actually thought that human beings *looked like* the rather bewildering images we automatically associate with their work: heads seen in profile yet bearing a full-face eye; bodies viewed frontally from the waist up yet sustained by legs drawn sideways and planted on two left feet. These images are not childish attempts to represent the human form. Rather, they proceed from the desire to incorporate all the most distinctive attributes of the body (movement and stillness, for example) within one single shape.

Following the rules of conceptual abstraction rather than the principles of naturalism, Egyptian artists were opposed to distortions meant to make an image appear realistic. Tricks such as *perspective* and *foreshortening*, for instance, would have been regarded as offensive.

WHEN THESE TECHNIQUES ARE USED, BODIES AND OBJECTS LOOK VERY MUCH THE WAY THEY DO IN REAL LIFE. BUT THEY ALSO LOSE THE AURA OF WHOLENESS WHICH THEY ENJOY IN STYLIZED PICTURES. FOR EXAMPLE, A FORESHORTENED LIMB LOOKS CONVINCING BY NATURALISTIC STANDARDS.

REALLY?

But by Egyptian standards it looks as if it's been cut off. The body of its owner is accordingly seen as disabled: in other words, not a fitting representation of the ideal body.

The 'Body' of the Work

A representation is a physical object because it has a 'body' which, like the human body, is subject to change and corruption. Parts of a painting, for example, can alter and deteriorate for a number of reasons.

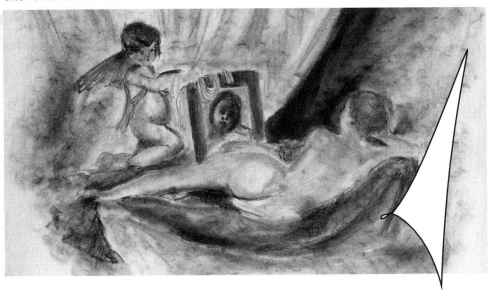

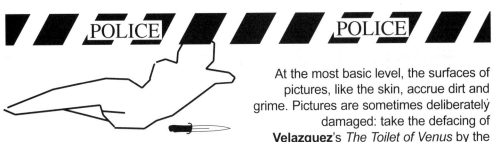

At the most basic level, the surfaces of pictures, like the skin, accrue dirt and grime. Pictures are sometimes deliberately damaged: take the defacing of **Velazquez**'s *The Toilet of Venus* by the militant suffragist Mary Richardson in 1914. Richardson's act was interpreted by many as an assault not only on the body of the painting but also on the body of the nation and its cultural values.

Sometimes, pictures are accidentally damaged. Most often, alterations in the picture's body have to do with the materials and techniques originally used by the artist, and with excessive efforts on the part of restorers keen to 'improve' the picture. In the past, it was not unusual for paintings to be modified by the addition of fig leaves and veils meant to conceal 'unseemly' portions of the human anatomy.

What makes a representation a 'work of art'? The 'artiness' of a work is not a result of the materials used by its maker: art uses the same raw materials which we find in non-art. And it's not a result of what is done to those materials, either: anybody who makes anything (not just the artist) *does* something to her/his materials by transforming them into an object or shape. Perhaps what distinguishes the work of art from other objects is the fact that it makes us aware that it has been *constructed* by someone and for someone.

Bricks found on a building site are objects with a practical function: we don't generally think about the processes through which they were produced. But we respond differently to **Andre**'s *Equivalent VIII,* the famous arrangement of bricks in the Tate Gallery. Whether we regard it as a great work or as trash, we can't dodge the fact that it was designed and assembled to be displayed in a museum, not to serve any other material purpose.

I APPRECIATE THE UNIDEALIZED TRANS-MUTATION OF LIFE-LIKE REPRESENTATION INTO A RECONCILIATION OF THE VISIBLE...

Another interesting case is that of **objets trouvés** or 'found objects'. These are works made from things which the artist didn't have to create because they were already there - bicycle wheels, tins, toilet units, etc. Strictly speaking, there is nothing arty about these objects but they become artworks when the artist *picks them out* and moves them from their familiar context into another, unexpected one. Such works remind us that all artists assemble pre-existent materials. The originality of their task has less to do with *invention* than with the imaginative *selection* and *relocation* of anything available.

'Work of art' is a ubiquitous term. It is used so often and in so many different ways that it ends up indicating something very vague. All we actually know about the work of art is that it is a product of two factors: the imagination and the observation of the world. The imagination is the creative power that looks at the world and translates it into images. The artist doesn't merely 'imitate' nature.

Nature creates its own works according to particular laws and mechanisms. For all we know, nature is not actually *conscious* of performing these creative processes. The artist, by contrast, is conscious of what s/he is doing.

NATURE

S/he might not always know where an idea comes from or where exactly s/he's heading. But s/he is aware that s/he is engaged in a process of transformation of ideas into images.

But we should not forget, in describing art in such broad terms, that concepts such as the 'imagination', 'nature' and 'imitation' are not timeless. They are always tied to a context and to an ideology. For example, we must be aware that prevailing definitions of art are rooted in a western tradition which has repeatedly marginalized 'other' cultures.

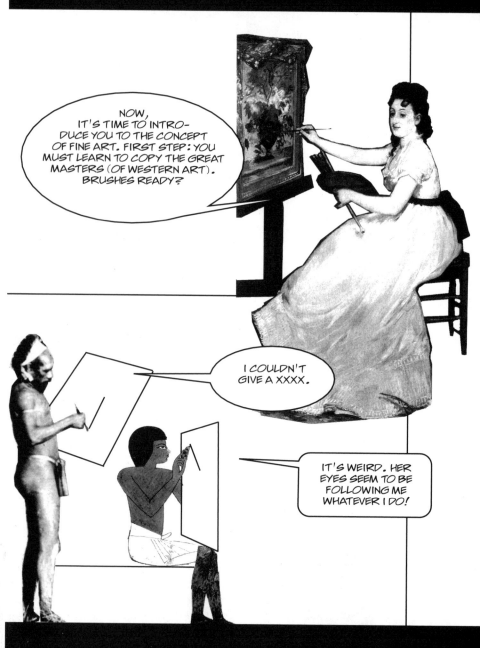

Art and the 'Other'

Dominant ways of thinking about art have, until recently, been fundamentally Eurocentric. Since the Renaissance, Western European culture has continuously defined itself in relation to other cultures. Europeans have constructed their identities by differentiating themselves from what they are not - or don't wish to be. A huge variety of non-European cultures have been clustered together as the Other to sustain this process of self-definition.

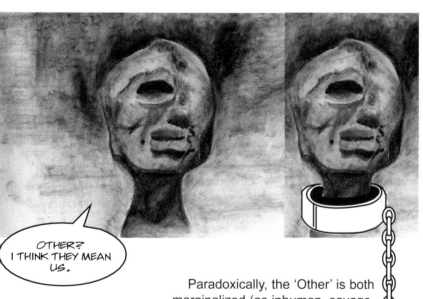

OTHER?
I THINK THEY MEAN US.

Paradoxically, the 'Other' is both marginalized (as inhuman, savage, cannibalistic or, at best, naive) and incorporated into western art. For example, so-called 'primitive' artefacts from African tribal cultures and Australian Aboriginal art have influenced deeply the development of modern art. Although western art conventionally claims to have moved beyond 'primitivism', it is undeniable that 'other' traditions have invigorated it substantially.

They have supplied western artists with new themes, styles and techniques, and with the means of challenging tradition. Artists are not always familiar with the cultures from which they borrow and this lack of adequate knowledge can give rise to legion misconceptions and stereotypes. But their artistic experiments are greatly enriched by contact with the 'Other'.

I CAN'T QUITE PUT MY FINGER ON IT, BUT THERE'S SOMETHING STRANGELY FAMILIAR ABOUT THAT PAINTING.

Maybe an artist like **Gauguin** was just romanticizing what he saw as the primitive spirit, but hi paintings undoubtedly challenged many conven tions of established European art. **Picasso** wa probably fairly unfamiliar with the ethnographi details of the tribal sculptures he was imitating Yet he succeeded in translating their mood int powerful and often very humorous images a odds with the *official* values of urban culture

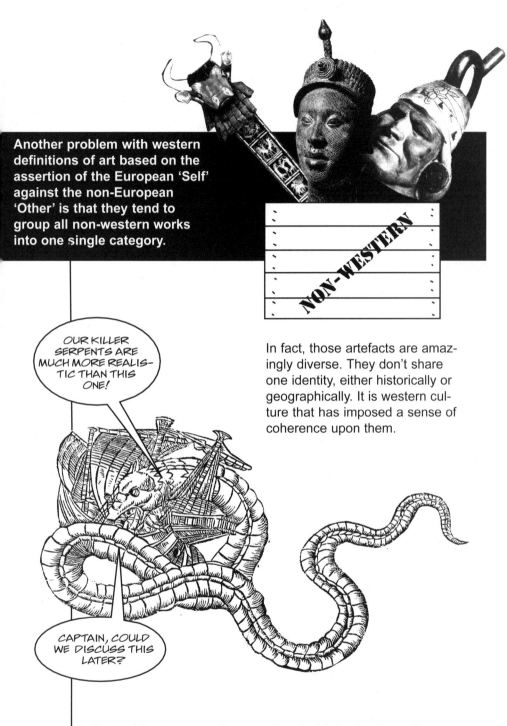

Another problem with western definitions of art based on the assertion of the European 'Self' against the non-European 'Other' is that they tend to group all non-western works into one single category.

NON-WESTERN

OUR KILLER SERPENTS ARE MUCH MORE REALISTIC THAN THIS ONE!

In fact, those artefacts are amazingly diverse. They don't share one identity, either historically or geographically. It is western culture that has imposed a sense of coherence upon them.

CAPTAIN, COULD WE DISCUSS THIS LATER?

In the Middle Ages, people were already fabricating fantastic images of the terra incognita, the unknown world beyond the boundaries of Christendom. Those 'mysterious' lands were invariably associated with monstrosity and extravagance.

The Renaissance voyages of 'discovery' reinforced this tendency. The objects brought back to Europe by the explorers were measured against a western 'norm' of beauty or taste and hence regarded as outlandish, strange, *inexplicably different*. They were objects of *curiosity*. And they had to be somehow controlled, put into a category which western culture could 'understand'. A way of doing this was to collect them and put them on display in 'cabinets of curiosities'. *The art of other cultures could only be grasped as a deviation from the natural norm.*

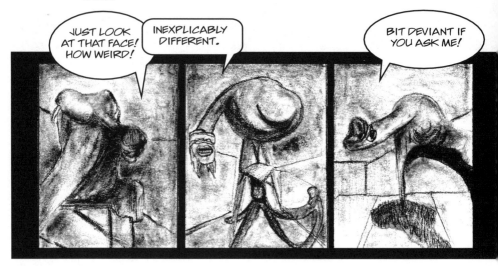

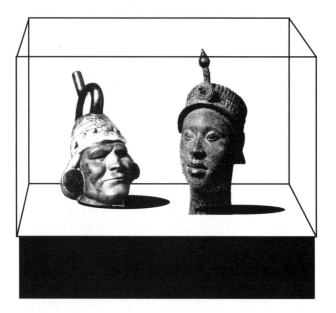

At times, the exotic character of the artefacts was taken as a sign of those cultures' inhumanity. At others, it was seen - patronizingly - as a sign of their lack of sophistication and refinement.

Since the early 19th century, artworks from non-western societies have been interpreted and classified by the institution of the 'museum'. Museums order and exhibit objects according to their places of origin, their places in history, and their subject matter. Sometimes they focus on the evolution of forms over time in a range of cultures. Sometimes they are more concerned with the cultural history of a specific society

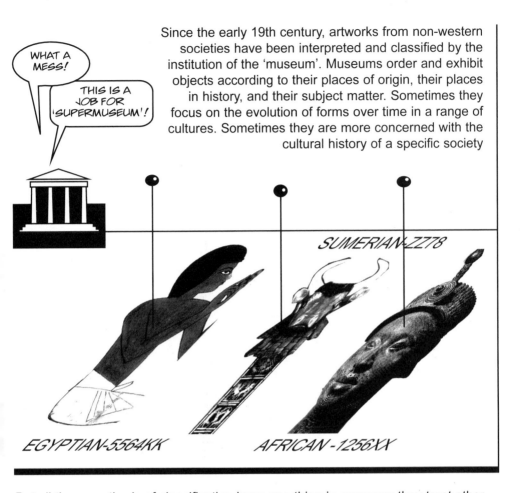

But all these methods of classification have one thing in common: they treat other cultures as 'alien'. They adopt racial and social stereotypes to make other cultures intelligible to the western public.

In recent years, all sorts of definitions of art have been questioned by **postmodernism**. Postmodernism is suspicious of ideas of truth and objectivity. It argues that these ideas are relative and culturally determined. It's up to artists (and scholars, and writers) from previously colonized regions to provide their own accounts of 'other' art and of its distortion by western art.

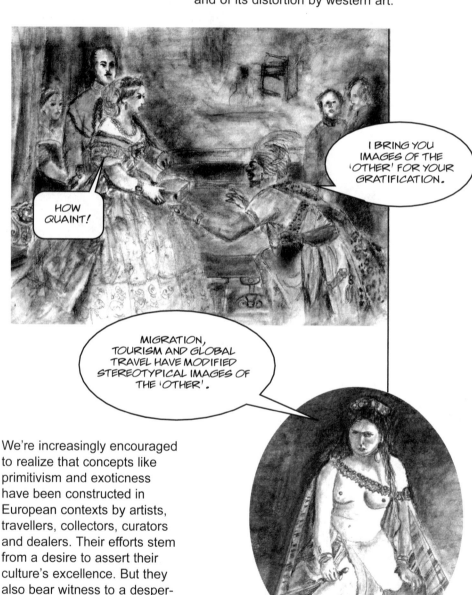

I BRING YOU IMAGES OF THE 'OTHER' FOR YOUR GRATIFICATION.

HOW QUAINT!

MIGRATION, TOURISM AND GLOBAL TRAVEL HAVE MODIFIED STEREOTYPICAL IMAGES OF THE 'OTHER'.

We're increasingly encouraged to realize that concepts like primitivism and exoticness have been constructed in European contexts by artists, travellers, collectors, curators and dealers. Their efforts stem from a desire to assert their culture's excellence. But they also bear witness to a desperate need to understand what that culture was all about in the first place!

Art as Document

Definitions of art alter according to time and place: images are ways of reflecting on both everyday life and momentous events.

The Image as Record

Amongst other things, images are 'documents' which give us insights into cultural transformations, the history of fashion, and the growth of a civilization. Sometimes we can reconstruct the history of a people through images, even if no written texts are available or if the existing ones are written in unknown languages.

Take some simple examples. Egyptian paintings and sculptures can communicate even to the viewer who is unable to decipher hieroglyphics many things about that culture's dress codes, its objects, commercial activities, religious ceremonies. The same can be said of Greek art. Its decorated vases are a gold-mine of information about both everyday life and mythological events. Vivid images of ships and chariots, dancing women, artesans at work, banquets and theatrical performances, gods, heroes and satyrs enable us to reconstruct important aspects of Greek culture.

Images also register important shifts in the history of costume and bodily adornment. Portraits offer an inexhaustible gallery of clothes and accessories, materials, fabrics, and jewellery. Their symbolic meanings are complex and the modern viewer is often unable to grasp all their connotations. How many of us know that in the Renaissance a particular flower was supposed to symbolize chastity, another passion, another friendship? But even the non-professional viewer will be able to form a picture of a culture's tastes through the observation of its costume.

JUST LOOK AT THOSE HATS. HOW SCREAMINGLY OLD-FASHIONED!

PRECURSOR OF THE CLOCHE, I'D SAY.

If we know when a portrait was painted, we can gather data about the styles in vogue in that year. Conversely, if we don't know when the painting was made, we may be able to give it a date on the basis of the fashions it represents. But artists sometimes dress mythological or religious figures in the clothes of their times. Several 15th-century representations of the Trojan war show figures garbed in the robes fashionable at that time moving amongst Gothic buildings. At this point, the image has a double documentary role: it tells us both about the artist's interpretation of a legendary episode and about the artist's perception of her/his own world.

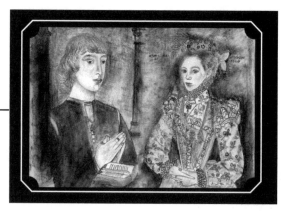

Works of art often act as documents not only by telling us things about the societies in which they were originally created but also by showing us how an artefact can be recycled by later cultures. For example, works or fragments of works from the Greeks and the Romans record aspects of the Classical era. But they go on speaking well after that. Their voices can still be heard in the Christian age, when it was common to preserve Roman gems, coins, and gold or silver artefacts as church treasuries. Roman sarcophagi were often reused as coffins for prestigious people. And fragments of columns from Classical temples could be incorporated in religious buildings.

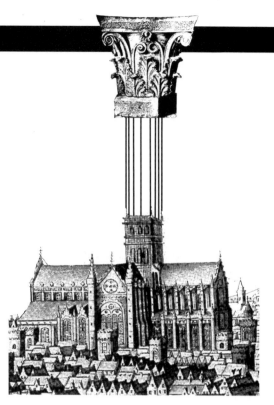

THIS RECYCLING BUSINESS ISN'T SO MODERN AFTER ALL.

Much as Christianity might have wished to dissociate itself from the pagan world, parts of that world remained alive in the Middle Ages. And they play their role as documents in two ways. First, they bear witness to the enduring legacy of Classical antiquity. Second, they demonstrate that the *history of art* is never a question of neat breaks with the past and fresh starts, but rather a process of constant recycling and reinterpretation.

33

In the Renaissance, artists and patrons were eager to assert the importance of human values and deeds, and rejected the medieval idea that people were helpless puppets in the hands of God.

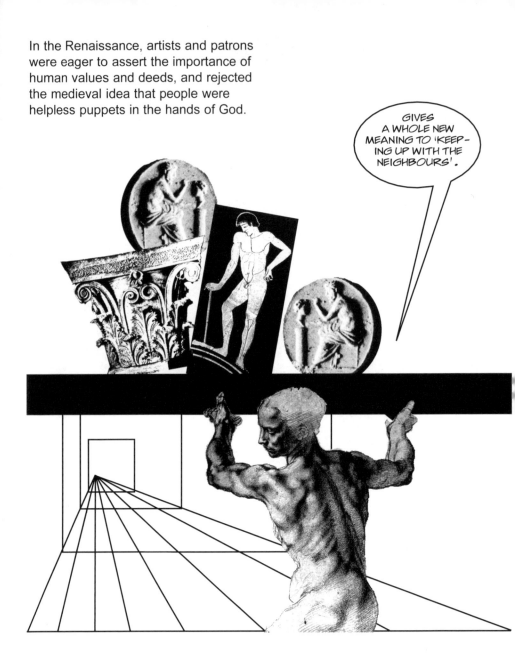

They turned to the pre-Christian cultures of Greece and Rome to support their world view, and avidly collected all sorts of artefacts from Classical times. Again, ancient works don't simply tell us about antiquity. They also record the aspirations of a more recent world.

In the 18th century, it became practically compulsory for young aristocrats to give a finishing touch to their education by undertaking a 'Grand Tour' of Europe that would show them all the great sights, especially Classical remains.

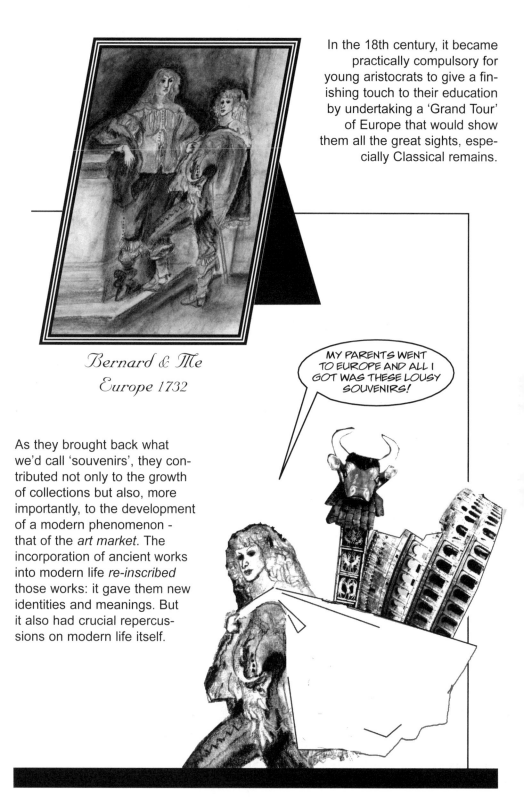

Bernard & Me
Europe 1732

As they brought back what we'd call 'souvenirs', they contributed not only to the growth of collections but also, more importantly, to the development of a modern phenomenon - that of the *art market*. The incorporation of ancient works into modern life *re-inscribed* those works: it gave them new identities and meanings. But it also had crucial repercussions on modern life itself.

MY PARENTS WENT TO EUROPE AND ALL I GOT WAS THESE LOUSY SOUVENIRS!

There came a point when people were no longer satisfied with just collecting things. They also wanted to 'know' where they came from, what they meant, what their value was. They wished to become 'connoisseurs'. This marked the beginnings of Art History as a discipline in its own right. Especially influential was the publication of **J.J. Winckelmann**'s *History of Greek Art* in 1754. At the same time, it became possible to place ancient works in their contexts through the birth of another discipline, Archaelogy. Excavations gave people insights into the material circumstances of ancient cultures: town-planning, interior design, domestic utensils.

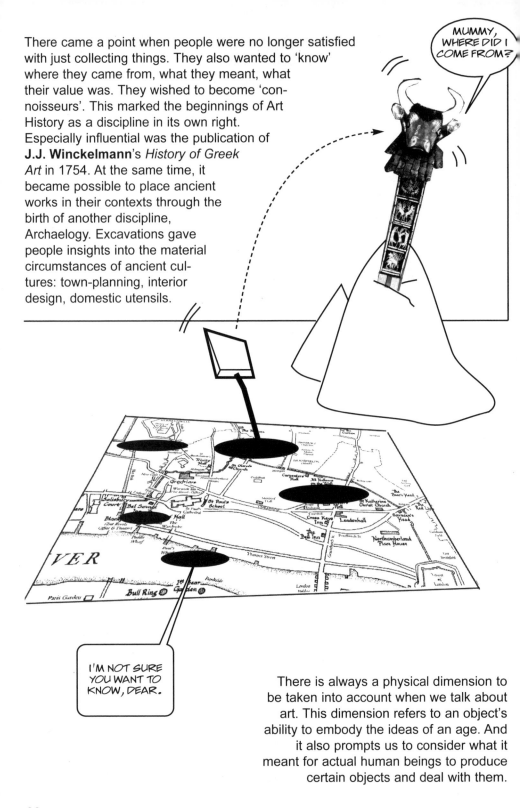

There is always a physical dimension to be taken into account when we talk about art. This dimension refers to an object's ability to embody the ideas of an age. And it also prompts us to consider what it meant for actual human beings to produce certain objects and deal with them.

Facts and Fictions

Images do not simply mirror 'facts'. Pictures create worlds with a language of their own. They interpret events through specific tools and techniques. The relationship between a pictorial representation and the thing represented is not based on *natural resemblance*. We cannot say that a painting of the birth of Venus 'resembles' the event it depicts, for that event might never have taken place.

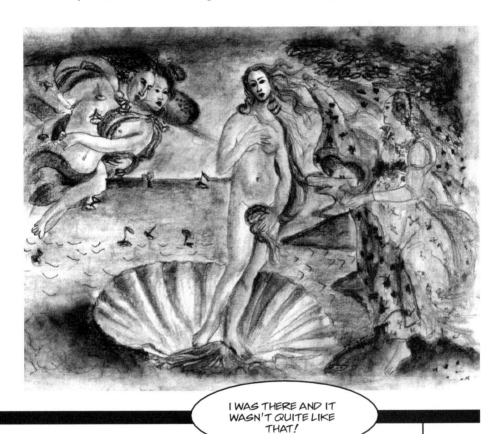

I WAS THERE AND IT WASN'T QUITE LIKE THAT!

We cannot even say that a portrait 'resembles' a face, because more is at stake in a person's artistic representation than sheer physical likeness. And we cannot say that a painting of a historical event 'resembles' it because the artist has necessarily processed the event through both personal and cultural filters: *constructed* it pictorially.

When we talk of the documentary value of art, we must bear in mind that what art gives us is inevitably an 'interpretation' of a world, a society or a social group. The 'facts' recorded by artists are inseparable from the 'fictions' which a culture ceaselessly tells about itself and to itself.

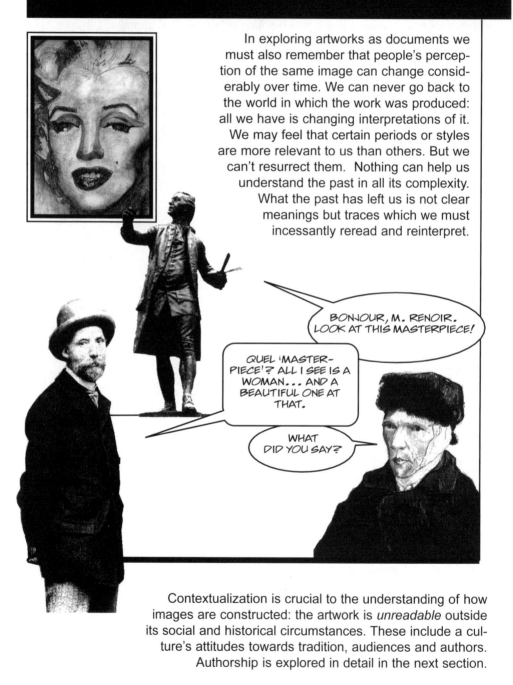

In exploring artworks as documents we must also remember that people's perception of the same image can change considerably over time. We can never go back to the world in which the work was produced: all we have is changing interpretations of it. We may feel that certain periods or styles are more relevant to us than others. But we can't resurrect them. Nothing can help us understand the past in all its complexity. What the past has left us is not clear meanings but traces which we must incessantly reread and reinterpret.

BONJOUR, M. RENOIR. LOOK AT THIS MASTERPIECE!

QUEL 'MASTERPIECE'? ALL I SEE IS A WOMAN... AND A BEAUTIFUL ONE AT THAT.

WHAT DID YOU SAY?

Contextualization is crucial to the understanding of how images are constructed: the artwork is *unreadable* outside its social and historical circumstances. These include a culture's attitudes towards tradition, audiences and authors. Authorship is explored in detail in the next section.

The Concept of the Artist

An artist is an author. But what is an 'author'? An 'extraordinary' person cut off from society or a mirror of that society's beliefs?

I HAVE NO IDEA...

Questioning 'Genius'

The word 'author' comes form the Latin augere which means 'to make grow', 'to produce'. But it is also associated with the ideas of authority and authoritarian behaviour. It is both a liberating and a restrictive concept.

In 1977, **Roland Barthes** wrote an essay entitled 'The Death of the Author' which deeply affected contemporary ways of viewing authorship.

Barthes gives greater prominence to the reader (and, by implication, the viewer) of a work. The work's meaning is more a product of its perceiver's interpretation than of its maker's *intentions*. Interpretation, it must be added, is never conclusive: the work doesn't have one single meaning to be 'discovered' but rather offers vast galaxies of signs that can be followed in many directions.

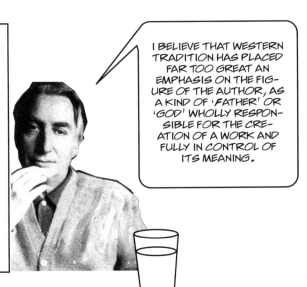

I BELIEVE THAT WESTERN TRADITION HAS PLACED FAR *TOO* GREAT AN EMPHASIS ON THE FIGURE OF THE AUTHOR, AS A KIND OF 'FATHER' OR 'GOD' WHOLLY RESPONSIBLE FOR THE CREATION OF A WORK AND FULLY IN CONTROL OF ITS MEANING.

No less influential has been **Michel Foucault**'s essay 'What is an Author?' (1978). Foucault argues that the 'author' is not a person but a concept which can only be grasped in terms of social, political and historical circumstances. Foucault prefers the phrase *author-function* to the word 'author'. This function refers to a body of works, ideas, theories and values associated with an author's name rather than a physical individual.

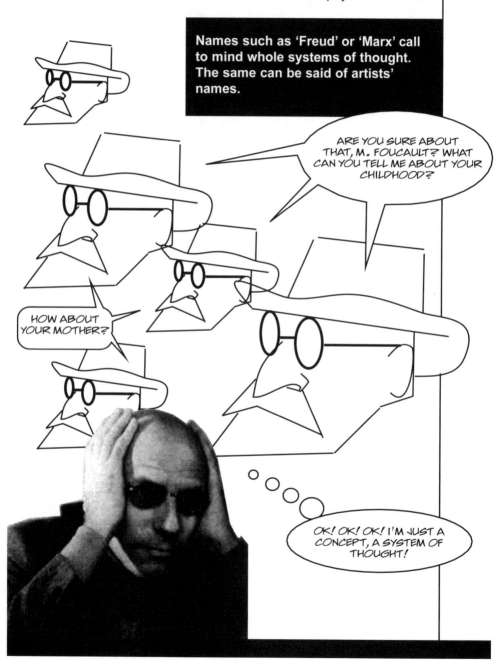

Names such as 'Freud' or 'Marx' call to mind whole systems of thought. The same can be said of artists' names.

ARE YOU SURE ABOUT THAT, M. FOUCAULT? WHAT CAN YOU TELL ME ABOUT YOUR CHILDHOOD?

HOW ABOUT YOUR MOTHER?

OK! OK! OK! I'M JUST A CONCEPT, A SYSTEM OF THOUGHT!

These views have done much to undermine conventional idealizations of the artist as a 'genius'. In the ancient world, what people meant by genius was the particular spirit of a place, family or clan. Later, genius came to refer to a guardian spirit. An individual's genius was what made her/him different from everybody else.

I JUST KNOW I'M A GENIUS. NOT THAT I'M BIG-HEADED ABOUT IT.

But in more recent times, genius was used to describe a person of exceptional intellectual and imaginative power. The artist became an extraordinary being. Critiques of authorship such as the ones initiated by Barthes and Foucault contribute to the explosion of this myth. They encourage us to wonder whether genius is really a superior force that transcends space and time. If this were the case, why should all so-called geniuses be white and male?

Our views on the artist's role change as the result of social and economic shifts. At times, the artist may seem to speak on behalf of a whole community; at others, s/he may represent an exclusive class, circle or elite; at others still, the artist may operate as an isolated, even controversial individual. At all times, however, there is no consensus over what an artist is.

I'VE ALWAYS WANTED TO MEET A REAL ARTIST.

WELL, YOU'RE IN LUCK!

SO, WHAT IS AN ARTIST?

WELL... UM... I'LL GIVE YOU A CALL.

Take a few examples...

In prehistoric times, the artist was a 'maker', or 'homo faber', able to give visible shape to symbolic ideas. The image lived half way between art and ritual. In medieval societies, the artist was often a *bard* who played an active part in social organizations - both in courtly circles and in street life. In reciting epic deeds to a group of noblemen or to a market crowd, s/he acted as the spokesperson for a community

In the Renaissance, artists mainly worked for patrons: the aristocracy or the Court. One of their main responsibilities was to express the cultural identity of a class or nation. The artist's role was fundamentally *public*. In the 18th century, artists were no longer so clearly tied to patrons. But they still played a public part because they were expected to express general ideas prevalent in their culture.

In the age of Romanticism, artists were seen for the first time as members of a fundamentally 'professional' caste. The Romantic artist was also an isolated figure. Some people think that the artist's apartness from society was a form of escapism: a refusal on the artist's part to engage with social and political questions. But the Romantics didn't necessarily choose solitude.

IT WASN'T A FORM OF ESCAPISM, BUT I CERTAINLY NEED ONE NOW.

RATHER, WE WERE PUSHED INTO IT BY A RAPIDLY CHANGING WORLD, WHICH HAD LITTLE TIME FOR CREATIVITY AND WAS FAR MORE CONCERNED WITH COMMERCE AND PRODUCTION.

Although some artists of the period were keen on cultivating an individualistic and often eccentric image of personal 'genius', they were also deeply concerned with politics - with the impact of industrialization and of the French Revolution of 1789.

Shifts in the artist's social role go hand in hand with important changes in the material circumstances of artistic practice. Let's look at some of the major institutions involved in this process.

In the Middle Ages and early Renaissance, artistic activity took place in the 'bottega' (the Italian word for 'shop' or 'workshop'), a studio run by a 'master'. Works produced in the bottega were collaborative efforts executed by assistants and apprentices under the master's supervision. There wasn't a single 'author' for these works. Up until the 16th century, art-making was controlled by the *guilds*, such as 'societies' of painters and sculptors. They comprised a guild 'master', his qualified 'assistants' (or *journeymen*) and young 'apprentices'.

AFTER FIVE OR TEN YEARS' TRAINING, YOU MIGHT BE ADMITTED TO THE GUILD.

HOW LONG?

FIVE OR TEN YEARS?

After an apprenticeship, an artist would move from one master's workshop to another as a journeyman, until he became free to set up his own business. Guild workshops followed strict rules and routines. When the new artist was received into the community, he was sworn to secrecy and had to protect the guild's interests and tricks of the trade. Every member of the guild had to accept his place in the hierarchy.

YES. BUT ONE DAY... I'LL BE RUNNING MY OWN BUSINESS!

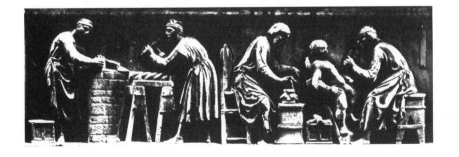

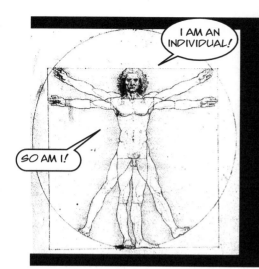

But there came a point when new philosophies about art and the artist's role required different arenas for the production of artworks. The philosophy of Renaissance humanism, in particular, stressed the importance of the individual and made the guild's cooperative activities look outmoded. On the economic level, the emergence of mercantile classes (what could be termed the 'proto-capitalists') did much to prioritize individual over group performance.

The guild system went out of fashion, as individual artists were given prominent roles, and distinguished figures started patronizing the arts. The two key institutions in the artist's world became *patronage* and the *academy*.

Let's take patronage first...

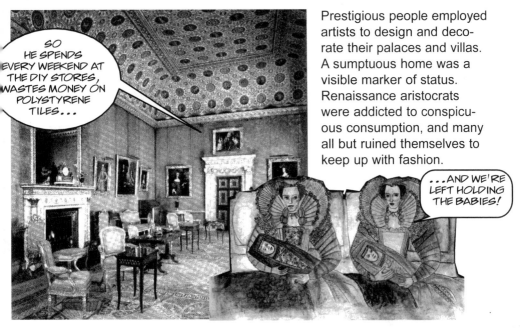

Prestigious people employed artists to design and decorate their palaces and villas. A sumptuous home was a visible marker of status. Renaissance aristocrats were addicted to conspicuous consumption, and many all but ruined themselves to keep up with fashion.

In Italy, where most governments were unstable and illegitimate, the rulers' support for the arts became a way of strengthening their identity and reputation. The artist was often a powerless pawn in an intricate political game: his job was to lend legitimacy to precarious organizations. Architecture allowed for the most public expression of the patron's prestige. But painting could also be profitably used as a form of propaganda.

ROYAL PORTRAITS AND ALLEGORICAL IMAGES IDEALIZED MANY RENAISSANCE RULERS INTO GOD-LIKE FIGURES. IN KEEPING WITH THE PHILOSOPHY OF THE DIVINE RIGHT OF KINGS, THESE IMAGES EXPRESSED A RULER'S RIGHT TO ABSOLUTE POWER.

A few painters achieved astonishing rewards and enviable titles for furthering this cause. Amongst them were **Gianlorenzo Bernini** (1598-1680), **Peter Paul Rubens** (1577-1640), **Sir Anthony Van Dyck** (1599-1641) and **Diego Velazquez** (1599-1660). Rubens is an especially interesting case: as he moved from court to court across Europe, painting portraits and historical pictures, he also played a significant role as a diplomat. This case reminds us that although artists working under patronage were frequently tools in the hands of unscrupulous rulers, they could also achieve high status.

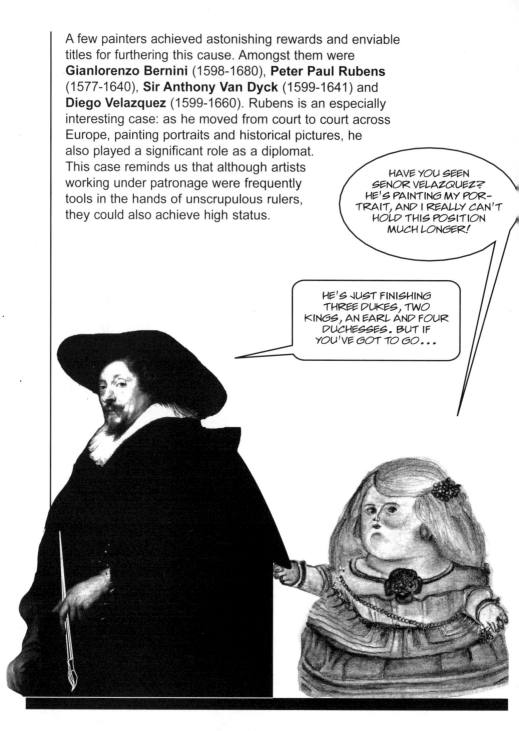

The type of artist most likely to obtain recognition was the one who could embody the virtues of one of the most emblematic Renaissance figures: the 'courtier'.

The courtier must endeavour to incarnate the Renaissance ideal of 'Universal Man': be a good orator, master many arts, display sophisticated social manners and know how to handle diplomatically the court's personal and political intrigues. Of course not all courtiers were artists, and not all artists were courtiers. But artists who worked under courtly patronage were often expected to fashion themselves according to the model of the perfect courtier.

WITH A BIT OF PRACTICE, I COULD PLAY CHESS TOO!

One of the qualities they had to develop was *dissimulation*. Living in a duplicitous environment, given to subterfuge and deception, the artist had to learn to establish prudential relationships with both princes and peers. But 'dissimulation' wasn't simply understood in the modern sense of the term - as sneakiness, or even dishonesty. Dissimulation was also an artistic skill. It meant being able to grasp elaborate symbols and images, and to give them form in correspondingly complex works of art. Plain truths were of scarce interest to courtly audiences. What they valued most was riddles. This is one of the reasons for the tremendous popularity of *allegory* throughout the period.

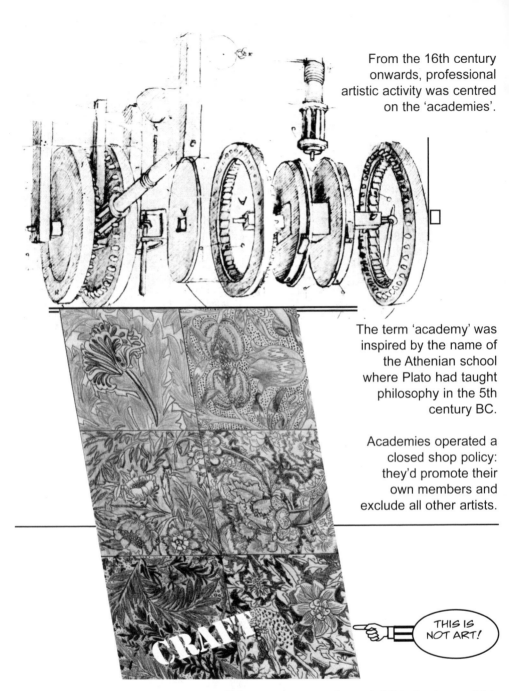

From the 16th century onwards, professional artistic activity was centred on the 'academies'.

The term 'academy' was inspired by the name of the Athenian school where Plato had taught philosophy in the 5th century BC.

Academies operated a closed shop policy: they'd promote their own members and exclude all other artists.

CRAFT

THIS IS NOT ART!

The first academies founded in the 16th century wanted to establish the laws which govern the making of artworks. They didn't want artists simply to produce beautiful objects. They also wanted art to be guided by unchanging rules. A fundamental principle they held was that fine art should be neatly distinguished from craft. The fine artist was supposed to follow intellectual and creative guidelines, while the craftsman was associated with a mechanical type of exercise.

SIGNOR VASARI, HERE'S THE MONEY.

CHEERS, DUKE. I'LL FOUND THE FIRST ACADEMY STRAIGHT AWAY!

The first academy, the 'Accademia del Disegno', was founded in Florence in 1563 by (1511-74) under the patronage of Grand Duke Cosimo I de Medici. Its students were required to draw from ancient samples. Special emphasis was put on the study of the nude, both in life classes and anatomy lessons.

LATER ACADEMIES FOUNDED IN ITALY, FRANCE AND ENGLAND WILL GO ON ENCOURAGING OUR PRACTICES.

Student artists had to spend most of their time making copies of Classical works and of Renaissance masterpieces, mainly paintings by **Raphael** and **Michelangelo**. In the late 17th century, academies also started lecturing their students. By and large, lectures would expound the 'greatness' of a work of art without telling the audience very much at all about practical aspects of picture making. This kind of academic teaching was meant to impart universal precepts about artistic value, not to help people understand how different materials and techniques could be used. The English Royal Academy of Arts, established in 1768, perpetuated this trend by preaching absolute standards of taste, beauty, virtue and harmony, based on *universal* and *rational* principles.

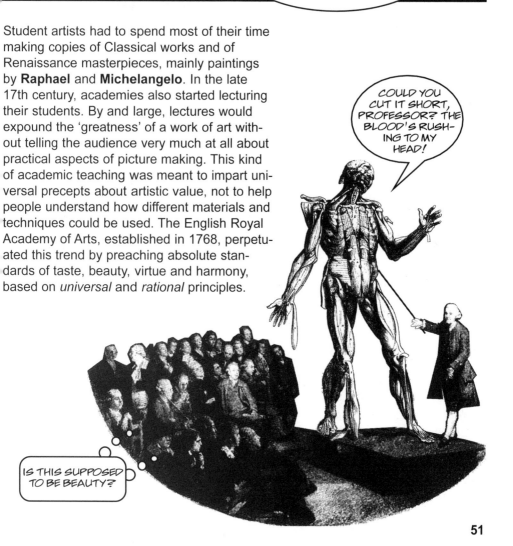

COULD YOU CUT IT SHORT, PROFESSOR? THE BLOOD'S RUSHING TO MY HEAD!

IS THIS SUPPOSED TO BE BEAUTY?

The values promoted by an academy were not purely artistic. They were also ideological: they expressed a culture's belief systems. Academies came about at a time when new structures of government were emerging in many parts of Europe. As nation states replaced local communities, new artistic policies had to be established. Art could no longer express the values and interests of a narrow portion of human society. It was required to convey the *spirit* of a whole nation through particular associations.

This made academic training very *prescriptive*: there was little scope for innovation and experiment. When they were first established, the academies were meant to give individual producers more freedom than they'd had in the guild system. But it soon became clear that academies were keen to inculcate particular values and styles, and that these had to reflect a strong sense of national identity.

In the 19th century, academies were undermined by two factors: the Romantic admiration for the independent artist; and the growth of bourgeois (rather than exclusively aristocratic) patronage, of private training schools, exhibition societies and art dealers.

The academic distinction between fine art and craft was also challenged. The **Arts and Crafts Movement**, developed in the second half of the 19th century.

WE BELIEVED THAT ALL SORTS OF ARTEFACTS COULD CONTRIBUTE TO A WELL-DESIGNED ENVIRONMENT – NOT JUST BUILDINGS, SCULPTURES AND PAINTINGS, BUT ALSO FURNITURE, CERAMICS, JEWELS AND CLOTHING. AND A WELL-DESIGNED ENVIRONMENT CONTRIBUTES, IN TURN, TO IMPROVING THE FABRIC OF SOCIETY.

William Morris (1834-96), one of the Movement's founding fathers, emphasized that the value of an artefact depends to a large extent on the material conditions under which it has been produced.

An object shouldn't be simply 'beautiful': it should also be the product of fulfilling labour. Work, for Morris, is a supreme expression of creativity and humanity. But people can only derive pleasure from handicraft: industrialized factories are bound to produce alienation and toil.

In the early 20th century, two main changes took place: institutions such as art schools and exhibitions became quite independent of academic influence; and new organizations were established whose objective was to narrow the gap between fine art and industrial art. Morris had opposed production for a mass market. But later artists and designers inspired by the Arts and Crafts Movement thought that industrial technology had beneficial things to offer

Instead of looking down on mass production as 'unarty', they believed that modern industry afforded opportunities for manufacturing a variety of objects economically without sacrificing creativity and beauty. Especially influential was the design school called Bauhaus, founded in Weimar in 1919 by the architect **Walter Gropius**. The Bauhaus artists had clear aesthetic ideals as far as design was concerned. They wanted their artefacts to be simple and practical, yet stylish and elegant. And they believed that the machine age could help them achieve this aim. They designed objects suitable for industrial manufacture and used materials such as plastic and chrome.

Since then, many things have concurred to redefine the figure and function of the artist. Although many art schools still operate on the assumption that traditional training is the foundation of a 'good' artist, art practice is being increasingly challenged by the development of new media.

CYBERNETICS, IN PARTICULAR, GIVES ARTISTS THE CHANCE TO PRODUCE IMAGES IN RADICALLY DIFFERENT WAYS BY DIGITAL MEANS.

The growth of electronic media has an impact not only on the role of the artist but also on how her/his works are presented to the public. Traditional exhibition spaces are beginning to be replaced by virtual galleries and electronic museums. People can 'visit' these cyberspaces without having to leave their homes, and can interact with the materials they see, disassembling and reassembling them in a variety of ways.

54

Woman as Artist

Changes in the cultural perception of the artist clearly show that there is no universal definition of the artistic personality. Artists can only be understood as functions of specific social and political contexts. But artists have also been ideologically defined on the basis of *gender*. This realization is of central importance to contemporary theorizations of art and its role in society. Since the late 1960s, fundamental questions have been asked about the part played by women in the arts. Three main issues are at stake in the debate on female artists:

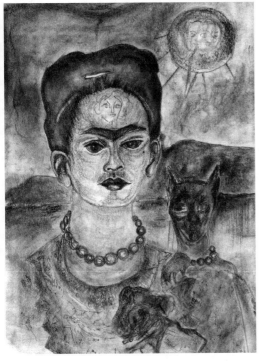

① The histories of neglected women artists must be rediscovered, in order to redefine a male-dominated 'canon' and reassess conventional notions of 'tradition';

② Representations of women by male artists must be 'reinterpreted' - i.e. appreciated not just in terms of their aesthetic merit but also in terms of the methods they employ to construct specific versions of femininity;

③ The role of art history as a discipline must be understood in relation to the values of a patriarchal culture, which has directed art-making in line with the interests of male authority.

But when we talk about 'women artists', we must be mindful not to put all women in the same category simply because they happen to be women. There is no universal female subject, any more than there is a universal idea of the artist. Individual women artists are not only defined by the fact that they are women and are engaged in artistic practices. They are also shaped by class, ethnic background and sexuality. Revisions of the canon undertaken in the west by white and heterosexual critics have often left out lesbians and women of colour, for example.

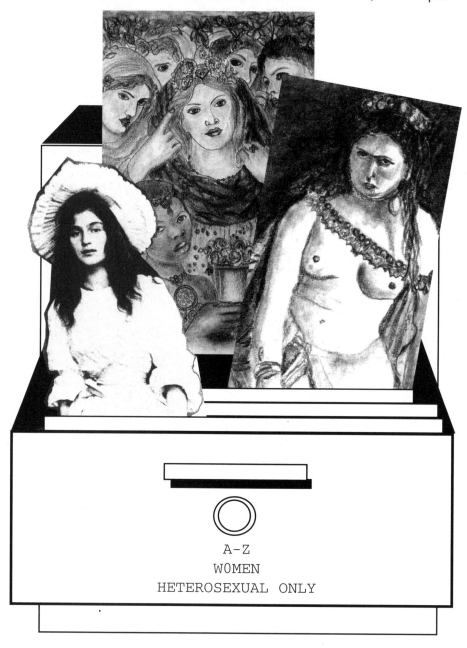

Black women throughout history have been doubly marginalized. Since the early stages of colonization, black people generally were seen as savage. The 'primitive' was to the 'civilized' as 'woman' was to man'. Being both black *and* a woman meant being not simply primitive but *hyperprimitive*.

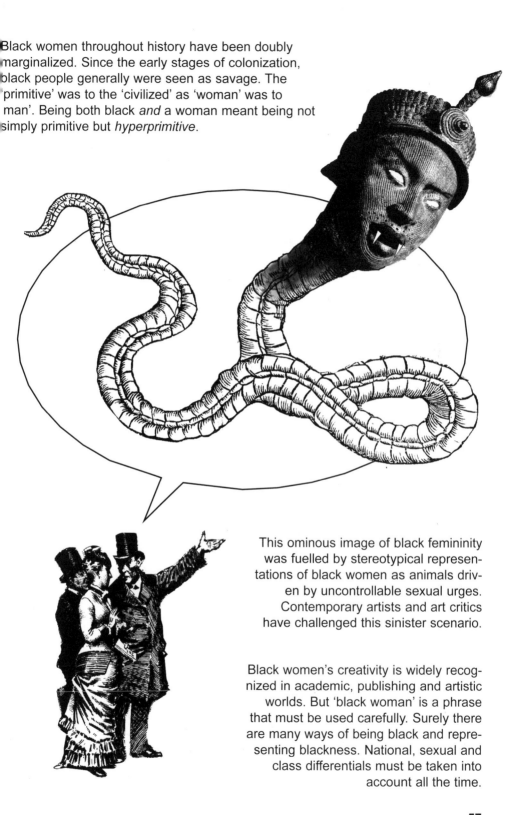

This ominous image of black femininity was fuelled by stereotypical representations of black women as animals driven by uncontrollable sexual urges. Contemporary artists and art critics have challenged this sinister scenario.

Black women's creativity is widely recognized in academic, publishing and artistic worlds. But 'black woman' is a phrase that must be used carefully. Surely there are many ways of being black and representing blackness. National, sexual and class differentials must be taken into account all the time.

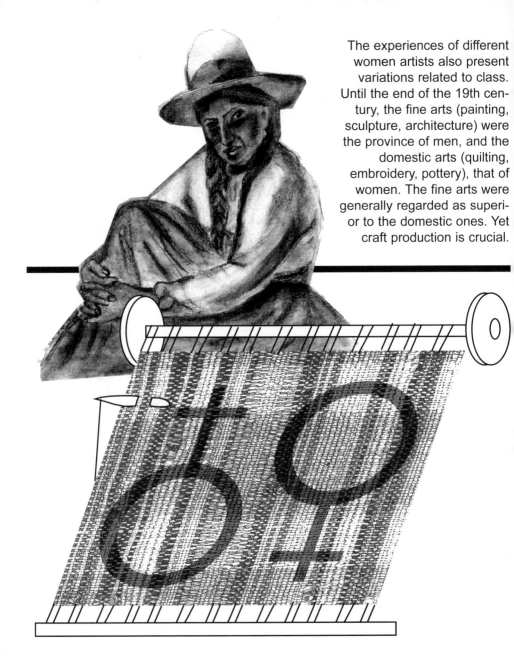

The experiences of different women artists also present variations related to class. Until the end of the 19th century, the fine arts (painting, sculpture, architecture) were the province of men, and the domestic arts (quilting, embroidery, pottery), that of women. The fine arts were generally regarded as superior to the domestic ones. Yet craft production is crucial.

Several impressive works by various Latin American women artists emphasize the creative significance of arts such as weaving and cooking. These domestic activities have enabled them to encode the values of a 'hybrid' culture, of perpetuating ancient practices, of negotiating western influences, and of engineering imaginative encounters between disparate traditions. But western culture has by and large scorned practical arts.

When, eventually, a fine art education for women became available, it was only open to middle-class and upper-class women. Working-class women still only had access to the acquisition of craft skills. And even where the more privileged women were concerned, fine art was seen as a way of refining their *femininity*, not of encouraging their creativity. As a result, women were generally confined to the 'lesser' media and genres: water-colour rather than oil; still-life paintings and landscapes rather than the nude. The 19th-century woman artist would have few opportunities to observe directly the public world that was rapidly changing around her.

THE LATE *19TH-CEN-TURY* CITYSCAPE WAS FULL OF ENERGY, VITALITY, EXCITEMENT AND GLITTERING CROWDS. (THINK OF URBAN SCENES REPRESENTED BY IMPRESSIONIST PAINTERS LIKE RENOIR.) *IT COULD SPARK A SENSE OF JOY* AND *FREEDOM!*

BUT IT COULD ALSO BE SCARY: THE SWELLING THRONG THREATENED TO ENGULF PEOPLE AND CARRY THEM AWAY IN ITS TIDE. 'RESPECTABLE' WOMEN SHOULD BE LARGELY EXCLUDED FROM THIS WORLD. THEY WERE SUP-POSED TO BELONG TO THE PRIVATE WORLD OF THE HOME. IT WAS ASSUMED THAT ONLY PROSTITUTES OR LOOSE AND WANTON WOMEN COULD TAKE PART IN THE LIFE OF THE STREETS...

...and these sorts of women were seen as menacing and unclean. They added to the sense of danger inspired by the bustling crowd by *contaminating* what was basically a man's territory. The common reaction to the presence of women in public spaces was that they just shouldn't be there.

Gradually women artists gained access to a greater variety of subjects than their training had originally allowed. For example, the Impressionist painters **Berthe Morisot** (1841-95) and **Mary Cassatt** (1844-1926) extended the thematic range available to women...

...BY DEPICTING HUMAN FIGURES, OFTEN ENGAGED IN INTIMATE ACTIVITIES LIKE BATHING. BUT THESE WERE STILL TIED TO THE DOMESTIC SPHERE, TO PRIVATE SITUATIONS, TO MOTHERHOOD AND CHILDREN.

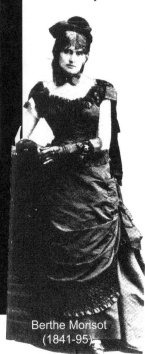

Berthe Morisot
(1841-95)

Moreover, both artists recorded aspects of a middle-class woman's experience. A working-class woman would have seen the world around her quite differently. If she had anything to do with art at all, she would be involved in vocational training. Or else she would be employed as a model by a male artist, which often meant that she could be exploited both financially and sexually.

PLEASE MONSIEUR, CAN WE GO? I'M FREEZING!

SURE, BUT IT'S A FIVE O'CLOCK START TOMORROW... BY THE WAY, WHAT ARE YOU DOING TONIGHT?

Women have consistently been excluded from the art world as 'producers'. But at the same time, they have been given key roles to play as the male artist's 'raw

material'. For centuries, female bodies have served as sources of inspiration for male creativity and action: as muses, for example, and as political symbols like *Liberty*. Women have been at the centre of many influential artistic messages. But they have seldom been granted the right to express significant messages of their own. Things have changed in many important ways since the 19th century.

Today, women *do* play a distinctive part in artistic practice. And the critical study of women artists and of images of women (produced both by women and by men) invites us to reassess our understanding of art history.

But neither the term 'woman' nor the term 'artist' can be used as blanket categories. The experiences of female artists are as varied and complex as those of male artists. So are their racial, social and political backgrounds.

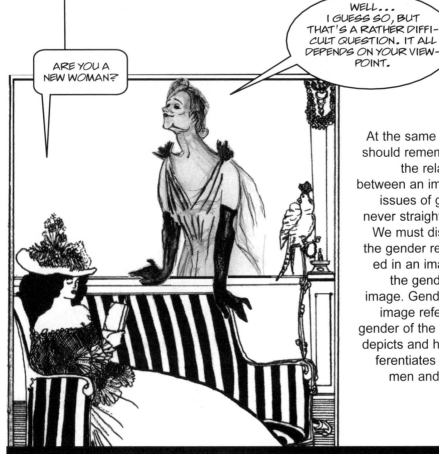

At the same time, we should remember that the relationship between an image and issues of gender is never straightforward. We must distinguish the gender represented in an image from the gender of the image. Gender 'in' an image refers to the gender of the figures it depicts and how it differentiates between men and women.

The gender 'of' the image is more problematic: a picture which represents a female figure is not necessarily female if the figure has been represented from a male point of view. When we explore the place of women in the arts we must focus on their products and their own representations of themselves. But we must also relate those products and representations to the man-made images of women which, after all, still fill the majority of art books.

Aesthetics

The difficulty of defining art and the figure of the artist is addressed by divergent theories within aesthetics, i.e. the branch of philosophy concerned with our responses to art.

What is the 'Aesthetic'?

The word 'aesthetics' comes from the Greek *aesthesis*, which means 'perception by the senses', 'feeling', or 'sensitivity'. Aesthetics explores the ways in which objects are experienced by the senses. It focuses on feelings of pleasure and displeasure rather than on the practical functions of things.

SHE CERTAINLY SETS *MY* PULSE RACING!

The term 'aesthetic' was coined by **Alexander Baumgarten** (1714-62). Since then, aesthetic theory has been trying to establish how people respond to beauty and whether the perception of beauty ('taste') is universal or subjective.

Critics and philosophers are still divided over the issue of what 'aesthetics' really means.

Some critics have argued that the work of art embodies moral and social values. In the 1920s, **I.A. Richards** championed this view by maintaining that...

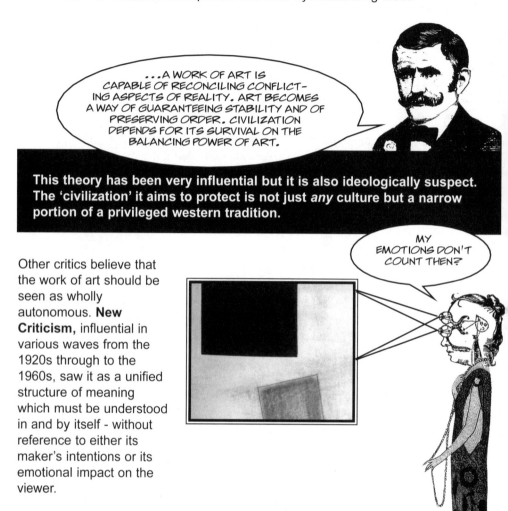

...A WORK OF ART IS CAPABLE OF RECONCILING CONFLICTING ASPECTS OF REALITY. ART BECOMES A WAY OF GUARANTEEING STABILITY AND OF PRESERVING ORDER. CIVILIZATION DEPENDS FOR ITS SURVIVAL ON THE BALANCING POWER OF ART.

This theory has been very influential but it is also ideologically suspect. The 'civilization' it aims to protect is not just *any* culture but a narrow portion of a privileged western tradition.

MY EMOTIONS DON'T COUNT THEN?

Other critics believe that the work of art should be seen as wholly autonomous. **New Criticism,** influential in various waves from the 1920s through to the 1960s, saw it as a unified structure of meaning which must be understood in and by itself - without reference to either its maker's intentions or its emotional impact on the viewer.

Formalism, which developed in Russia in the years around the 1917 Revolution, also argued that we should focus on the specificity of a work of art as a work of art rather than on its relation to history or politics. From the late 1950s well into the 1970s, **Structuralism** asserted that individual works should be linked to a broad system of meaning. Autonomy is an attribute of the system as a whole rather than of a specific work. The system is complete and self-regulating: it is governed by particular principles and rules which determine the character of the individual works which belong to it.

There are then those who argue that art is inseparable from society, ideology and politics.

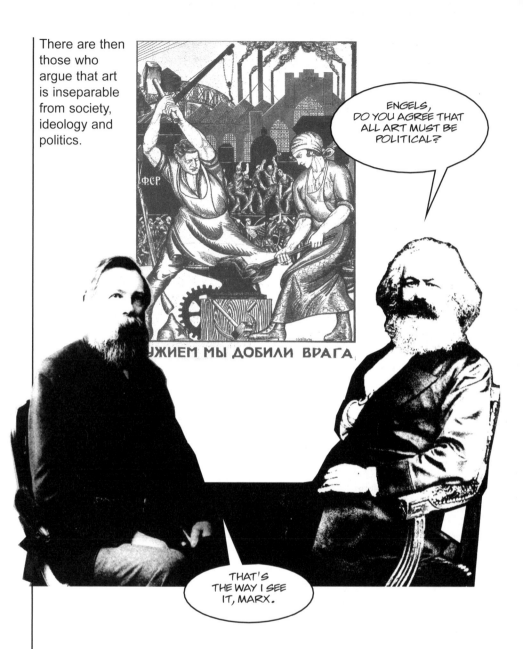

Various strands of **Marxist criticism** from the end of the 19th century to the present have stressed that there is no 'pure' notion of art, for art is what is *taken* to be art by a society or its key members. Western culture has insistently tried to insulate art from history to conceal the fact that definitions of art are always conditional on particular interests and world views. Making art into an absolute concept is a way of saying that values cannot change. In fact, definitions of art and of the aesthetic experience alter dramatically over time.

Exploring the Imagination

The faculty which enables us to process ideas into visible things is often described as the imagination. The ancient Greeks called this faculty *phantasia*, from *phos*, which means 'light'. Mental images are not just delusions but also a form of 'illumination'. They can give us insights into reality. The imagination gives us the initial images from which all further thought proceeds. Greek philosophers termed these images *phantasms*, a word which also derives from *phos*.

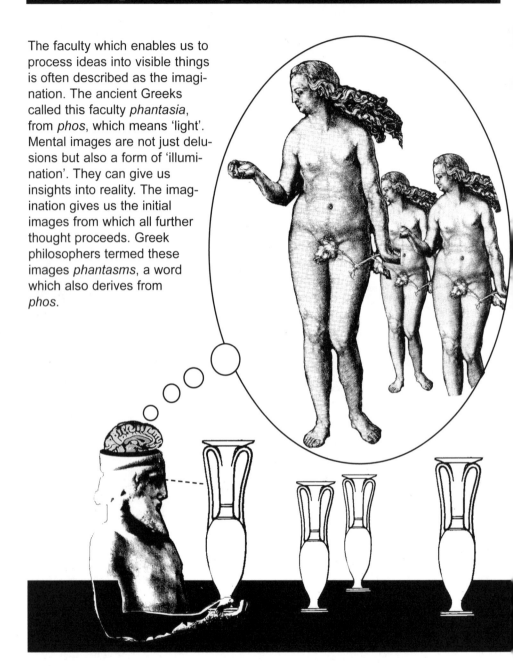

Yet western culture has often been unsympathetic to the imagination and its products. It has regarded those 'phantasms' as the figments of an eccentric brain.

Plato (c.428-347 BC) didn't approve of artistic creation. In his writings on inspiration, he compared the artist to a lunatic possessed by demonic powers. He thought that art was just about tolerable if it was used to teach people religious and moral values. But by and large, he disparaged it as the *copy of a copy*.

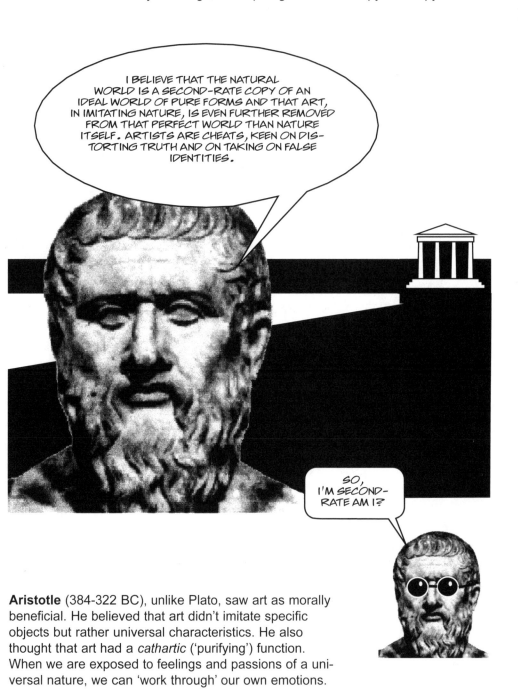

I BELIEVE THAT THE NATURAL WORLD IS A SECOND-RATE COPY OF AN IDEAL WORLD OF PURE FORMS AND THAT ART, IN IMITATING NATURE, IS EVEN FURTHER REMOVED FROM THAT PERFECT WORLD THAN NATURE ITSELF. ARTISTS ARE CHEATS, KEEN ON DISTORTING TRUTH AND ON TAKING ON FALSE IDENTITIES.

SO, I'M SECOND-RATE AM I?

Aristotle (384-322 BC), unlike Plato, saw art as morally beneficial. He believed that art didn't imitate specific objects but rather universal characteristics. He also thought that art had a *cathartic* ('purifying') function. When we are exposed to feelings and passions of a universal nature, we can 'work through' our own emotions.

In the Renaissance, many philosophers accepted that the imagination played an important part in helping us grasp the external world. But they also distrusted this faculty because they thought that it had a tendency to get out of control. The imagination was acceptable as long as it could be restrained by reason. Some philosophers and artists believed that the imagination had every right to create alternative realities. But they insisted that this was justifiable only as long as art's worlds could teach people fundamental truths.

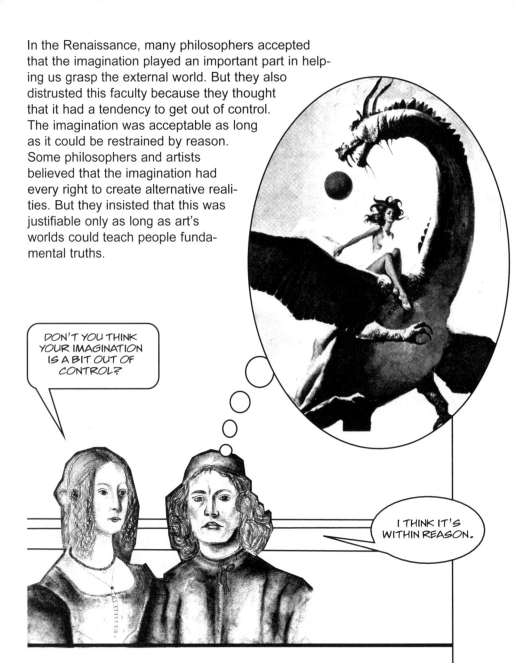

DON'T YOU THINK YOUR IMAGINATION IS A BIT OUT OF CONTROL?

I THINK IT'S WITHIN REASON.

In the late seventeenth and eighteenth centuries, the philosophy of **the Enlightenment** reinforced the message that human beings should be directed by the light of reason. The imagination was associated with superstition, ignorance and prejudice. The Enlightenment comprises two philosophical strands: **rationalism** and **empiricism**.

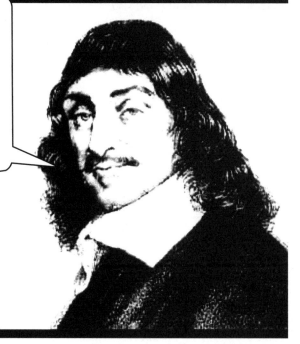

I WAS CONCERNED WITH DETECTING RATIONAL METHODS THROUGH WHICH WE CAN GAIN *OBJECTIVE KNOWLEDGE* OF THE WORLD. THEY MUST FOLLOW *INNATE IDEAS* WHICH ARE IN EVERYONE'S MIND FROM THE START. THE IMAGINATION COULD ONLY LEAD TO ERRORS OF JUDGEMENT.

Descartes wanted to believe that it is not the bodily eye but the abstract mind that sees and represents the world.

Empiricism, on the other hand, didn't count on purely abstract rules. **Thomas Hobbes** (1588-1679) believed that mental images are produced on the basis of sense impressions. We receive physical impulses through the senses and translate them into images. When the impulses stop, the images remain and go to form the imagination. Memory, for Hobbes, is *simple* imagination.

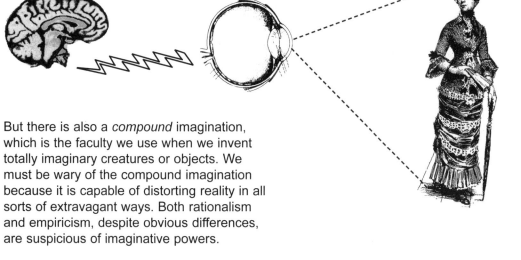

But there is also a *compound* imagination, which is the faculty we use when we invent totally imaginary creatures or objects. We must be wary of the compound imagination because it is capable of distorting reality in all sorts of extravagant ways. Both rationalism and empiricism, despite obvious differences, are suspicious of imaginative powers.

The battle against the imagination is an attempt to consolidate society by separating neatly the real and the unreal. An aesthetic ideology which says that we should all be guided by reason is repressive because it can only tolerate creativity if it is socially shared. To say that there are universally shared values (such as beauty and taste) is a way of denying that the world around us is competitive and chaotic and of fashioning a sense of community.

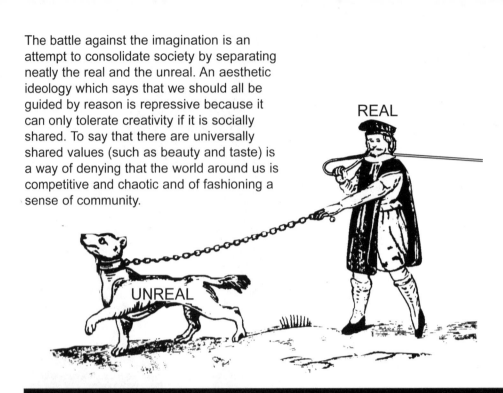

REAL

UNREAL

But the aesthetic community will only ever embrace a relatively small number of people. The sense of unity it advertises hides from view all those who are left out, their suffering and their exploitation.

It is not until the **Romantic** period that the imagination comes to be seen as a positive faculty. The poet and artist **William Blake** celebrated vision and inspiration, and created dream-worlds which blatantly rejected the 'tyranny' of reason.

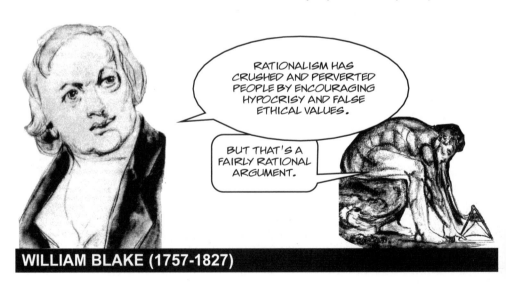

RATIONALISM HAS CRUSHED AND PERVERTED PEOPLE BY ENCOURAGING HYPOCRISY AND FALSE ETHICAL VALUES.

BUT THAT'S A FAIRLY RATIONAL ARGUMENT.

WILLIAM BLAKE (1757-1827)

Samuel Taylor Coleridge (1772-1834) advocated the need to distinguish between the *primary* and the *secondary* forms of the imagination.

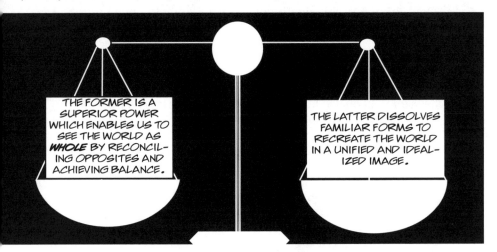

THE FORMER IS A SUPERIOR POWER WHICH ENABLES US TO SEE THE WORLD AS **WHOLE** BY RECONCILING OPPOSITES AND ACHIEVING BALANCE.

THE LATTER DISSOLVES FAMILIAR FORMS TO RECREATE THE WORLD IN A UNIFIED AND IDEALIZED IMAGE.

'Fancy', on the other hand, is only capable of dealing with fragments and can only supply a bitty and disconnected image of the world.

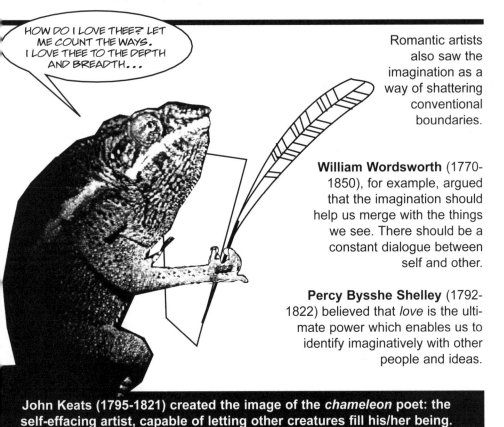

HOW DO I LOVE THEE? LET ME COUNT THE WAYS. I LOVE THEE TO THE DEPTH AND BREADTH...

Romantic artists also saw the imagination as a way of shattering conventional boundaries.

William Wordsworth (1770-1850), for example, argued that the imagination should help us merge with the things we see. There should be a constant dialogue between self and other.

Percy Bysshe Shelley (1792-1822) believed that *love* is the ultimate power which enables us to identify imaginatively with other people and ideas.

John Keats (1795-1821) created the image of the *chameleon* poet: the self-effacing artist, capable of letting other creatures fill his/her being.

Immanuel Kant believed that there are two levels of reality. One is the *phenomenal* world. This is the natural world which human beings perceive. He called it 'phenomenal' because he believed that we never know things as they truly are - as *things-in-themselves* - but only in terms of how they *appear* to us. ('Phenomenal' derives from the Greek word *phenomenon* = 'appearance'.) In the phenomenal world, we

perceive objects but cannot truly *know* them because we are only ever in touch with their surface appearances, not with their intrinsic essences. And then there is the *noumenal* world. This is the world of ideas (*noumena*), of deep truths. Reason tells us that this world exists but we cannot know it. We are able to think about it because, as moral creatures, we have a free will. But from a practical point of view, it remains beyond our grasp.

IMMANUEL KANT (1724-1804)

The aesthetic idea supplies a link between the noumenal and the phenomenal. When we experience things 'aesthetically', we are still tied to their appearances. But we also perceive a *design* in them which gives us a glimpse of the superior world of ideas. The aesthetic judgment is important on three counts.

It accords importance to the individual because 'beauty' is necessarily *subjective*.

It is *disinterested* because it doesn't seek gratification and is not concerned with material advantages.

It is *universal* because, although there is no immutable standard of taste, what is pleasing is *always* a matter of 'form' or 'pattern'.

Aesthetic feelings, argues Kant, emanate from either the *beautiful* or the *sublime*. A beautiful object is clearly defined; its beauty comes from the balance of its elements within closed boundaries.

A sublime object is limitless; it defies common standards through extreme greatness (the Mont Blanc in moonlight) or extreme energy (a stormy sea).

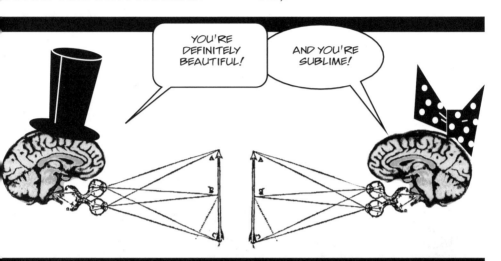

But neither beauty nor sublimity are properties of the object. Rather, they spring from the mind of the perceiver.

German Idealism tried to go further than Kant by denying the existence of 'things-in-themselves'. It argued that we create the world by perceiving it (words like 'idea' 'ideology', and 'idealism' comes from *idein*, the Greek word for 'to see'). **Georg Wilhelm Friedrich Hegel**, in particular, thought that the world is created by the ways in which the spirit sees it. The spirit is human consciousness in its entirety: a kind of world wide web which interconnects all individual consciousnesses. Hegel believed that this process of construction of the world by the spirit is *historical* and saw history in terms of progress and improvement. As humanity advances through history towards higher and higher ends, the spirit constantly recasts the world in different cultural and artistic forms. Cultures change all the time, but they are always expressions of the spirit. The rhythm of history is *dialectical*. This means that nothing is isolated. Everything must be seen in relation to its opposite. There is always a tension between two ideas (*thesis* and *antithesis*). The conflict must be resolved by reconciling opposite ideas into a new *synthesis*.

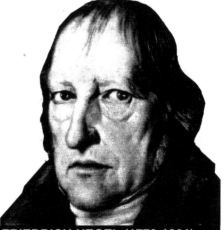

GEORG WILHELM FRIEDRICH HEGEL (1770-1831)

In ancient art, there is a conflict between 'symbolic' art (thesis) and 'classical' art (antithesis).

Hegel argues that symbolic art (e.g. the art of the Egyptians) is 'primitive', formless and not yet able to master beauty. Classical art (e.g. the Greeks) is capable of representing beauty and is sensitive to formal harmony and balance. But for Hegel, it is tied to the sensuous representation of the human body and is therefore still imperfect.

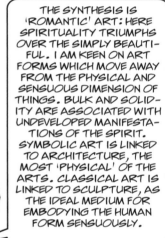

THE SYNTHESIS IS 'ROMANTIC' ART: HERE SPIRITUALITY TRIUMPHS OVER THE SIMPLY BEAUTIFUL. I AM KEEN ON ART FORMS WHICH MOVE AWAY FROM THE PHYSICAL AND SENSUOUS DIMENSION OF THINGS. BULK AND SOLIDITY ARE ASSOCIATED WITH UNDEVELOPED MANIFESTATIONS OF THE SPIRIT. SYMBOLIC ART IS LINKED TO ARCHITECTURE, THE MOST 'PHYSICAL' OF THE ARTS. CLASSICAL ART IS LINKED TO SCULPTURE, AS THE IDEAL MEDIUM FOR EMBODYING THE HUMAN FORM SENSUOUSLY.

Romantic art, finally, is linked to painting, music and poetry as art forms which depart from the physical and move towards the spiritual. At the end of the day, art's function is limited: art, like everything else, must be replaced by *philosophy* as the peak of 'pure consciousness'. Thus Hegel talked of the *end* of art.

Avant-Garde, Modernism, Postmodernism

But art hasn't ended yet. In fact, the 20th century has witnessed an amazing proliferation of movements keen to experiment with new visual languages. The term *avant-garde* is often used to describe these trends. There is no single identity for the *avant-garde*, and this is for two main reasons. First, various movements have produced hugely different art forms. Second, not all *avant-garde* artists have shared the same political beliefs.

But all *avant-garde* movements flaunt tradition and academic precepts in the search for novelty. They challenge convention and exhibit a rebellious attitude towards authority.

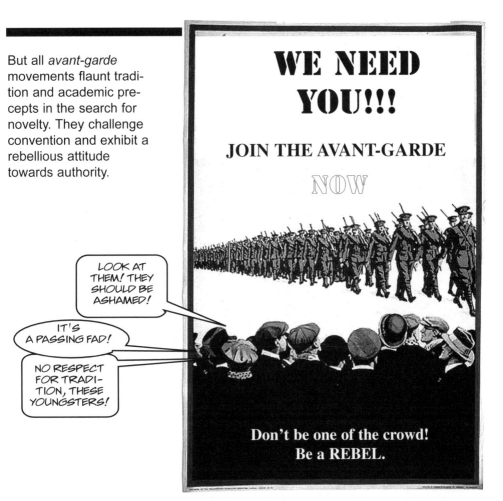

Interestingly, *avant-garde* was originally a military term referring to the foremost of an army. It was then used in France in the 19th century to describe politically progressive or socialist groups.

From there it came to designate thinkers and artists who 'lead the way'.

A crucial moment in the exploration of new aesthetic languages was the 1905 exhibition at the Salon d'Automne.

THERE WERE WORKS BY ME, ANDRÉ DERAIN (1880-1954), MAURICE DE VLAMINCK (1876-1958) AND OTHER ARTISTS. THESE PICTURES USED STRONG AND PURE COLOURS AND FLAT PATTERNS, AND WERE OVERTLY ANTI-NATURALISTIC.

THEIR REJECTION OF TRADITION MADE THEM DEEPLY SHOCKING TO MANY VIEWERS, TO THE POINT THAT THE ARTISTS WERE DISPARAGINGLY NICKNAMED 'FAUVES' (WILD BEASTS). HENCE THE TERM *FAUVISM*.

HENRI MATISSE (1869-1954)

No less momentous was the advent of **Cubism** in 1907-8. This movement came about from the collaboration between **Pablo Picasso** (1881-1973) and **Georges Braque** (1882-1963). These artists created a style based on the idea that an object shouldn't be represented according to how it is perceived by the naked eye.

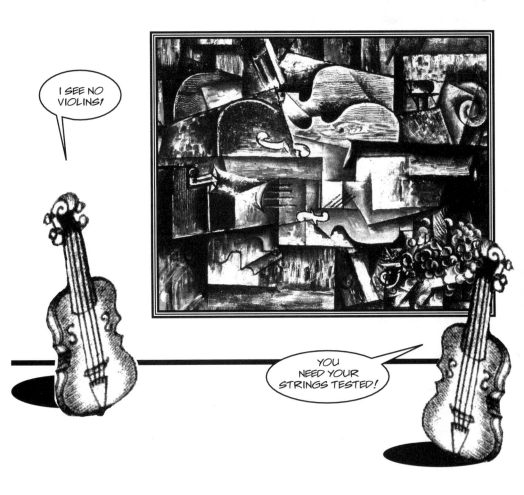

Impressionism had already undermined the idea of a solid reality by stressing that art shows what the artist perceives, not what s/he somehow knows to be there. Cubism went further. It claimed that an object doesn't have one absolute shape. Any object can be seen and represented from a huge variety of angles, and it will take on different forms and meanings depending on the angle from which it is perceived. Ideally, as many of these forms as possible should be represented within the same image. Both inanimate things and living bodies can be broken up into blocks and planes. And these can be juxtaposed and superimposed to create multiple images of the object. Both Fauvism and Cubism are important sources of inspiration for subsequent developments in modern art.

The concept of the *avant-garde* is closely linked to two major 20th-century phenomena: **modernism** and **postmodernism**.

Let's look at each in turn.

The term 'modernism' is generally used to describe an international trend which developed in the last years of the 19th century and went on to affect most 20th-century art.

Modernism is not a 'movement'. In fact, it comprises many different movements: **Symbolism**, **Impressionism** and **Decadence** around the turn of the century; **Fauvism**, **Cubism**, **Post-Impressionism**, **Futurism**, **Constructivism**, **Imagism** and **Vorticism** in the period up to and during World War I; **Expressionism**, **Dadaism** and **Surrealism** during and after that war. And the list is not exhaustive.

Just as modernism is not a unified movement or school, so it cannot be associated with one single art. It has influenced practically all the arts, in varying degrees: poetry, painting, architecture, fiction, drama, music, etc.

Broadly speaking, modernism is characterized by innovation and experimentation in the arts. Modernist artists wanted to dissociate themselves from the conventions of realism. They didn't believe that art could or should offer an objective reflection of reality. Nor did they think that what we call reality is a fixed world shared and recognized by everyone. The world that concerns modernism is a world of change rather than tradition, of transient and fleeting impressions rather than immutable forms. Modernist art rejects realism. It wants us to recognize that the artwork is an artifice, a construction.

SO, WE'RE CON-
STRUCTING A WORK OF
ART, ARE WE?

It places great emphasis on the devices and techniques employed to produce a particular work, and on the role played by *form* - rather than content - to convey certain messages.

Some cherished the modern city as a treasure-house of novelties. Others figured it as a crowded swamp filled with depravity. Those who saw modernity as exciting and progressive took pleasure in representing the world as full of movement, colour and light. But less optimistic artists depicted urban scenes dominated by distortion and excess.

But all artists had to confront a basic phenomenon: a radical transformation of western experience brought about by industrialization, urbanization, and the devastating effects of World War I. Economic, political and technological changes threatened to deprive the individual of any autonomy. Artists responded to this threat in a variety of ways.

Some modernist works suggest that the modern world is fundamentally a *marketplace*. Everything is caught up in financial markets and institutions. For example, **Edouard Manet**'s famous *Olympia* (1863) calls to mind great works of the past, such as female nudes painted by **Titian**, **Giorgione** or **Velazquez**...

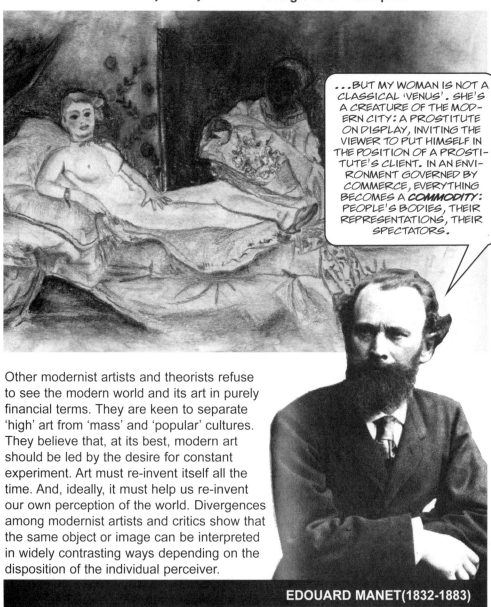

...BUT MY WOMAN IS NOT A CLASSICAL 'VENUS'. SHE'S A CREATURE OF THE MODERN CITY: A PROSTITUTE ON DISPLAY, INVITING THE VIEWER TO PUT HIMSELF IN THE POSITION OF A PROSTITUTE'S CLIENT. IN AN ENVIRONMENT GOVERNED BY COMMERCE, EVERYTHING BECOMES A **COMMODITY**: PEOPLE'S BODIES, THEIR REPRESENTATIONS, THEIR SPECTATORS.

Other modernist artists and theorists refuse to see the modern world and its art in purely financial terms. They are keen to separate 'high' art from 'mass' and 'popular' cultures. They believe that, at its best, modern art should be led by the desire for constant experiment. Art must re-invent itself all the time. And, ideally, it must help us re-invent our own perception of the world. Divergences among modernist artists and critics show that the same object or image can be interpreted in widely contrasting ways depending on the disposition of the individual perceiver.

EDOUARD MANET(1832-1883)

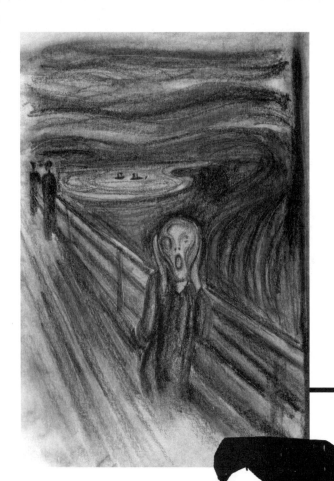

Some have criticized modernism for embracing such a subjective view of the world. They think that if we can't share anything with anyone else, we are doomed to loneliness and isolation. We become trapped in the prison of the individual self and incapable of collective action. Many modernist figures convey precisely a sense of alienation. **Beckett**'s and **Kafka**'s plays and novels, **Munch**'s paintings, **Giacometti**'s sculptures - to pick a few illustrations at random - clearly exemplify this tendency.

But those figures' helplessness doesn't necessarily make them socially or politically useless. Their estrangement from the world and their inability to make sense of what surrounds them forces us to reflect on conditions that are *very real indeed*.

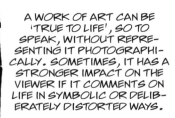

A WORK OF ART CAN BE 'TRUE TO LIFE', SO TO SPEAK, WITHOUT REPRESENTING IT PHOTOGRAPHICALLY. SOMETIMES, IT HAS A STRONGER IMPACT ON THE VIEWER IF IT COMMENTS ON LIFE IN SYMBOLIC OR DELIBERATELY DISTORTED WAYS.

Modernism rejected the idea of a single meaning but still trusted in art's ability to offer *deep* insights into what being human means or could mean. For **postmodernism**, there are only *surfaces*, fictions and stories. Some of the codes and conventions promoted by modernism could be rather restrictive. For example, some saw art as a superior form of expression available only to certain gifted individuals. Some thought that art is only valuable if it offers 'epiphanic' insights into reality (*epiphany* = revelation). Others wanted art to be totally 'pure' and disengaged from practical concerns.

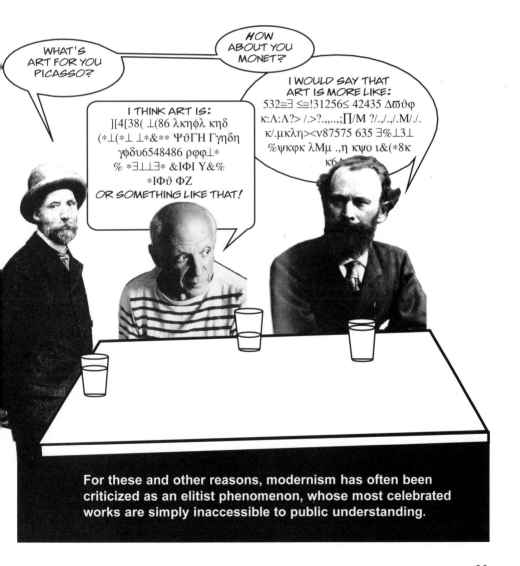

WHAT'S ART FOR YOU PICASSO?

HOW ABOUT YOU MONET?

I THINK ART IS:][4[38(⊥(86 λκηφλ κηδ (∗⊥(∗⊥ ⊥∗&∗∗ ΨϑΓΗ Γγηδη γφδυ6548486 ρφφ⊥∗ % ∗∃⊥⊥∃∗ &ΙΦΙ Υ&% ∗ΙΦϑ ΦΖ OR SOMETHING LIKE THAT!

I WOULD SAY THAT ART IS MORE LIKE: 532≅∃ ≤≅!31256≤ 42435 Δϖϑφ κ:Λ:Λ?> /.>?.,,..,;Π/Μ ?/.,/.,/.Μ/./. κ/.μκλη><ν87575 635 ∃%⊥3⊥ %ψκφκ λΜμ .,η κψο ι&(∗8κ κ6...

For these and other reasons, modernism has often been criticized as an elitist phenomenon, whose most celebrated works are simply inaccessible to public understanding.

Postmodernism, by contrast, doesn't follow any rigid rules. It claims that there are no *deep* meanings to be discovered, because meaning keeps shifting all the time. Words, images and signs lead to yet more words, images and signs, not to 'the truth'. Meaning is wholly dependent on context and moment. And no image or text is ever *unique*: images and texts are always related to other images and texts. This is what postmodernism calls *intertextuality*. Artists endlessly refer to other artists.

THERE ARE CERTAINLY MORE THAN 57 VARIETIES!

19¢

Campbell

CONDENSED

BEEF
NOODLE
SOUP

Sometimes they do this consciously, through art forms such as **pastiche**, **collage** and **montage**. But often they *borrow from* or *quote* other artists quite unconsciously. The point is that images are so deeply embedded in our culture that a lot of the time we find ourselves using them without being fully aware that we are doing so. Another way of putting this idea is that there are no individual *authors* for any of the images that surround us because images are the common 'property' of whole cultures. Images from an enormous range of different sources can be *appropriated* and placed in a new context.

This makes postmodernism a very 'eclectic' phenomenon, keen on a pluri-cultural range of styles and techniques. There is no monolithic definition of *the* postmodern text, because such a text can assemble together a limitless number of motifs.

But one feature of many texts produced in a postmodern culture is that they are *polyphonic*: they speak through many voices simultaneously. They draw from the contemporary world and from past traditions, from high culture and from mass culture. And they bring together images from various parts of the planet regardless of national and ethnic frontiers.

MARX & SPENDER SHOPPING CENTRE

In architecture, for example, there's been an explosion of shopping centres and malls full of details redolent of Classical buildings (keystones, arches, friezes, columns, fountains, vaults and domes) made entirely of glass and metal.

These things make postmodernism welcome as a form of release from restrictive rules. Indeed, many critics argue that postmodernism is a liberating phenomenon. Its emphasis on multiplicity, difference and movement is seen as a creative rejection of traditional ideals of unity, stability and uniformity. But others think that postmodernism has nothing imaginative to offer.

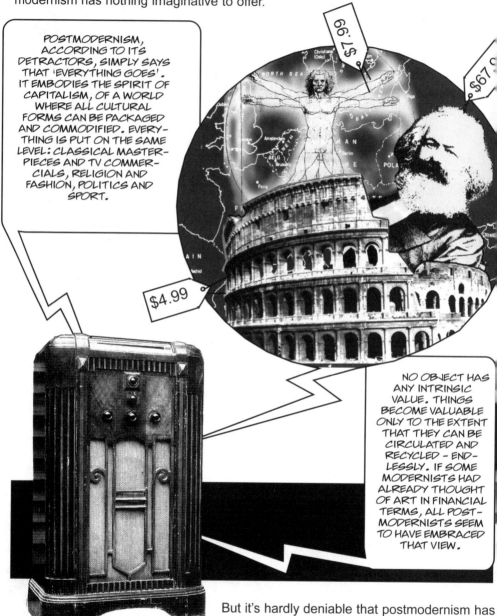

POSTMODERNISM, ACCORDING TO ITS DETRACTORS, SIMPLY SAYS THAT 'EVERYTHING GOES'. IT EMBODIES THE SPIRIT OF CAPITALISM, OF A WORLD WHERE ALL CULTURAL FORMS CAN BE PACKAGED AND COMMODIFIED. EVERYTHING IS PUT ON THE SAME LEVEL: CLASSICAL MASTERPIECES AND TV COMMERCIALS, RELIGION AND FASHION, POLITICS AND SPORT.

NO OBJECT HAS ANY INTRINSIC VALUE. THINGS BECOME VALUABLE ONLY TO THE EXTENT THAT THEY CAN BE CIRCULATED AND RECYCLED – ENDLESSLY. IF SOME MODERNISTS HAD ALREADY THOUGHT OF ART IN FINANCIAL TERMS, ALL POSTMODERNISTS SEEM TO HAVE EMBRACED THAT VIEW.

But it's hardly deniable that postmodernism has radically devalued many time-honoured western myths: authority, authorship, tradition, truth. Postmodernism marks a crucial shift in the status of art and the artist. And it may also offer us, the viewers, alternative ways of understanding our own place in contemporary culture.

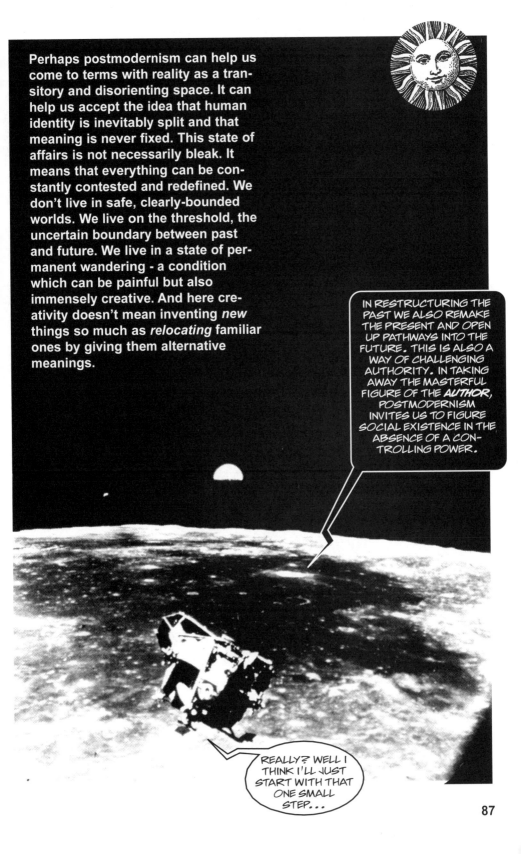

Perhaps postmodernism can help us come to terms with reality as a transitory and disorienting space. It can help us accept the idea that human identity is inevitably split and that meaning is never fixed. This state of affairs is not necessarily bleak. It means that everything can be constantly contested and redefined. We don't live in safe, clearly-bounded worlds. We live on the threshold, the uncertain boundary between past and future. We live in a state of permanent wandering - a condition which can be painful but also immensely creative. And here creativity doesn't mean inventing *new* things so much as *relocating* familiar ones by giving them alternative meanings.

IN RESTRUCTURING THE PAST WE ALSO REMAKE THE PRESENT AND OPEN UP PATHWAYS INTO THE FUTURE. THIS IS ALSO A WAY OF CHALLENGING AUTHORITY. IN TAKING AWAY THE MASTERFUL FIGURE OF THE *AUTHOR*, POSTMODERNISM INVITES US TO FIGURE SOCIAL EXISTENCE IN THE ABSENCE OF A CONTROLLING POWER.

REALLY? WELL I THINK I'LL JUST START WITH THAT ONE SMALL STEP...

87

Semiotics

In order to understand how a picture works (aesthetically or other-wise), we must be in a position to understand its language. We most often associate the word 'language' with the spoken or written word. But semiotic theory suggests that the label 'language' could be applied to all sign systems, including non-verbal and visual ones.

Reality and Perception

The 20th century has experienced a 'crisis' in representation. We no longer trust human beings' ability to paint 'truthful' pictures of reality. We are increasingly aware that our perception of the world is uncertain. We must always doubt what we see. Images don't represent reality but *perceptions* of it. The concept of perception replaces that of reality. But if perception is an unstable and open-ended process, who has the power to decide which ways of perceiving the world are valid and which aren't?

88

In any culture, ideologies and related institutions support particular ways of seeing and exclude others. When we see things in certain ways, we must always be aware that we would be seeing them in entirely different ways if the values of our culture were different. This makes our role as viewers an important and *active* one. Images are never finished or self-contained: they only exist in a *virtual* state which it is our task to fulfil.

In the course of the 20th century, many theories have been formulated about ways of perceiving things and making sense of them. For the purposes of this discussion, three ideas are especially weighty:

text, structure and play.

To begin with, *formalist* critics were concerned with the image as an independent text. They wanted the viewer/reader to focus on the text's particular use of themes and devices. Then the emphasis shifted from individual texts to structures. A text's specific features were seen as less significant than what the text shared with other texts.

Then *structuralist* critics were concerned with placing an image into a cluster of images, and with spotting connections, relationships and 'universal' ideas. But later theories have challenged the concept of structure.

Poststructuralist critics find the idea of a system of texts or images interlinked by universal principles restrictive - and far too neat! Poststructuralism has exploded structure and stressed instead the openness of language in all its forms. The various elements which form a text don't deliver a stable meaning. They hint at several possible meanings. And none of these is more reliable than any of the others. We don't progress from clues to truths, but from one clue to yet another clue, in a process of endless play.

We never experience artworks as objects in a vacuum. We always figure them in context. The context may be a museum, an art class, a TV programme, a computer programme, a book, a postcard, a calendar... this list could go on almost forever. An image gives us shapes and objects. But these are pretty meaningless in themselves. They gain meaning when we place them in certain contexts. And their meanings change as their contexts do. For example, one of **Cézanne**'s famous still-life paintings with jugs and oranges is likely to be seen as a work of art in the context of a gallery or in that of an exhibition catalogue...

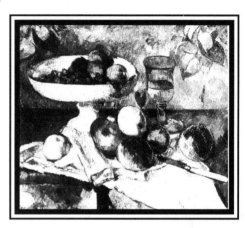

...but it's more likely to be regarded as a decorative motif if it features on a T-shirt or on a coffee mug. The image's shapes and objects remain basically the same, but our interpretations of them alter considerably according to their contexts. There isn't 'one' appropriate place for an image to occupy because images can be endlessly 'displaced'.

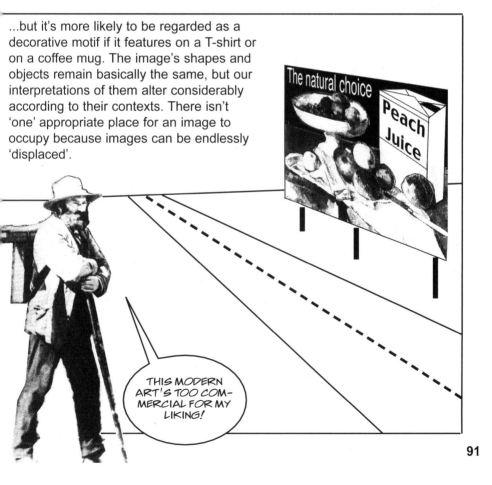

THIS MODERN ART'S TOO COM-MERCIAL FOR MY LIKING!

20th-century art has experimented with these two ideas in a variety of ways. Pop art, which developed in the US in the 1960s, offers some examples. **Roy Lichtenstein** (b.1923) worked with the techniques of mass culture to produce some of his most famous images. He selected frames from cartoon strips and reproduced them in oil on canvas, careful to simulate the screened dot technique. These paintings are so close to the original images that they could look as if the artist hadn't put any of his own imagination into them. But surely, cartoon frames become something quite *different* when they're taken out of their original context and turned into oil paintings. The viewer is asked to interpret them afresh. For one thing, they're no longer part of a sequence but stand as separate images. The line in the balloon is no longer a tiny fragment in a narrative but actually becomes a *story* in its own right.

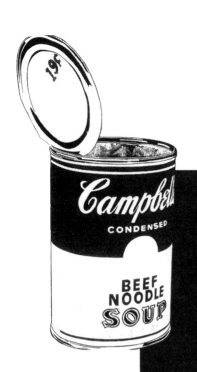

Andy Warhol (1928-87) used commonplace objects such as soup cans, Coke bottles, Brillo pads and money as the subjects of his paintings.

These items look so familiar that some viewers are not prepared to see them as art. But the displacement of a commercial image onto a painting *does* transform it. And it can also modify our interpretation of familiar objects. For example, if an everyday commodity can become a work to be displayed in a gallery, there's every chance that paintings themselves are, among other things, commodities.

New Realism (a term invented in 1960 with reference to an exhibition held in Milan at the time) also uses trivial and everyday objects. **Arman** (b.1928) filled glass cases with the contents of wastepaper baskets, or collections of forks and spoons. These objects are terribly familiar. But it's hard to see them as such when they are transposed to a different context. They become strange and uncanny. We remember seeing similar things in our kitchens but can't give them quite the same names.

The meanings of the objects represented in any image are the product of two factors: the places in which the objects are situated; and the viewer's interpretation of the relationship between things and their physical circumstances.

Working with Signs

Do images express what the world 'is' or what we 'take' it to be? What is the relationship between images and ideas? Can images 'say' something they don't mean? Can they 'mean' something they don't say? These are some of the questions addressed by semiotics in the course of the 20th century.

WHAT'S THE SIGNIFICANCE?

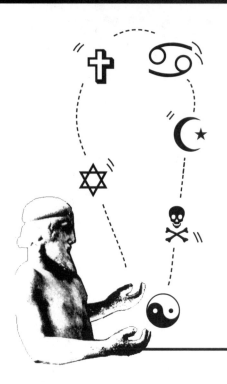

Semiotics (from the Greek word *semeion* = sign) is the science of signs. It studies the ways in which signs work in a culture. Everything can be read as a sign. From the point of view of semiotics, language includes all forms of signification (words, pictures, movements, gestures, buildings, clothes, furniture, menus, etc.). Understanding images semiotically means detecting and decoding their *sign systems*. Works of art are not frozen constructs. They are, above all, signs open to interpretation.

A sign is neither a 'thing' nor an 'idea'. It is something which 'stands for' a thing or an idea. When we hear or read words and when we see images, we don't hear/read/see actual things or ideas. Rather, we get clues which we must *interpret* in order to arrive at certain *meanings*. A picture's shapes and colours can stand for people, inanimate objects or abstract concepts. But when we look at the picture we don't see straightforward, prepackaged meanings. We perceive *allusions* to various possible meanings. We pick them up and translate them into something meaningful according to codes, conventions and habits of our culture. We are not always consciously aware of applying these rules.

The founders of modern semiotic theory are:

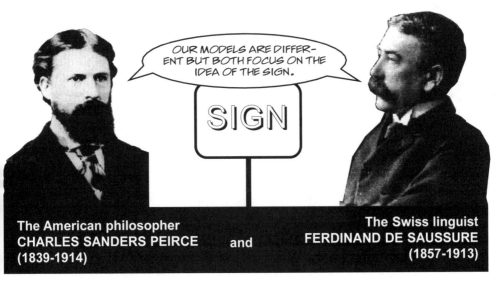

OUR MODELS ARE DIFFER-ENT BUT BOTH FOCUS ON THE IDEA OF THE SIGN.

SIGN

The American philosopher
CHARLES SANDERS PEIRCE
(1839-1914)

and

The Swiss linguist
FERDINAND DE SAUSSURE
(1857-1913)

Peirce argued that a sign is something which points to a meaning outside itself, and that the reader or viewer works out this meaning according to cultural conventions. If we apply this model to visual images, we find that decoding a picture involves three main things:

first of all, the viewer recognizes the picture as 'art' - because of its context rather than its content;

second, the viewer singles out the picture's most striking features - colours, methods of composition, symbols, cultural references;

third, the viewer perceives certain meanings in the picture: images have no meaning without a viewer willing to interpret them in accordance with particular codes.

Even saying that a picture is 'meaningless' or 'nonsense' (as some viewers do in the face of abstract art, for example) is a way of giving it a meaning. The image 'means' *meaninglessness* in terms of what the viewer's culture has defined as meaningful.

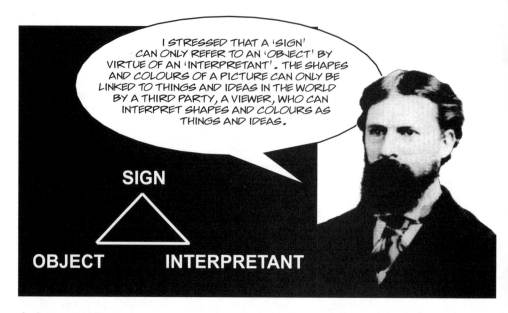

A sign can only evoke something outside itself if someone is prepared to see it *as a sign* and to link it to an aspect of reality. Of course, there are no fixed rules determining what can be seen as a sign and what can't. It's likely that we'll recognize a picture hanging in an art gallery as 'art' even if we don't like it. A picture dumped on a garbage heap by someone who was tired of it could still be recognized as an artistic sign. But how many people go rummaging through garbage heaps in search of discarded artworks? And can the dumped picture go on functioning as 'art' if nobody's there to see it?

Take another example. In the company of friends and colleagues, do we just take it for granted that they're wearing clothes because in western culture it's not quite acceptable to walk around in the nude? Or do we pick up each garment as a sign, a clue to these people's personalities? Obviously both options are equally tenable. Everything can become a sign, something meaningful beyond itself.

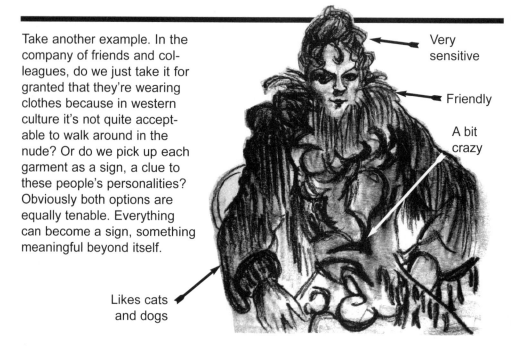

The viewer too is a sign. When s/he interprets signs, s/he does so on the basis of cultural codes and conventions, not on that of personal skills.

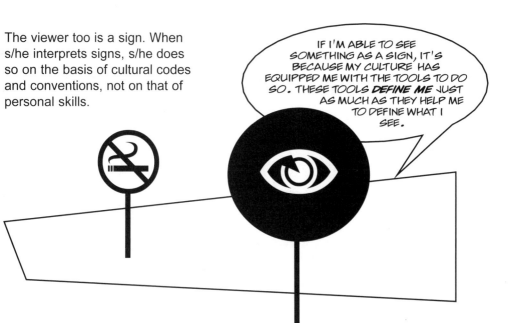

When a viewer looks at an image's signs and links them to objects in the world, the viewer is not 'explaining' the image. Rather, s/he is *interpreting* it. And all interpretations, needless to say, are always partial and subjective. The viewer doesn't produce a neatly bundled parcel of meaning there for everyone to share. What s/he produces, in interpreting a work, is always *another sign*. If I see a picture of a female figure holding an anchor, I'm likely to say to myself: 'this is a symbol of *Hope*'. I say this because certain visual conventions I've been taught tell me that 'woman' + 'anchor' = '*Hope*'. In Peirce's terms, the woman holding an anchor is a 'sign', which is associated with the 'object' *Hope* by me, the 'interpretant'.

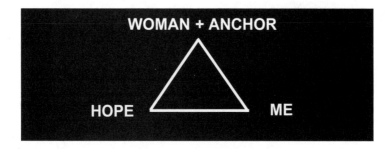

But I only interpret the image in this way because of my cultural training. If I belonged to a culture where female figures, anchors, and abstract concepts of Hope were totally unconnected, I wouldn't dream of coming up with such a reading. Nor would I make the connection if I hadn't seen similar pictures before. To someone who doesn't follow the same conventions as mine, 'woman' + 'anchor' = '*Hope*' is not a *meaning* but another *sign* requiring further interpretation.

In other words, when we interpret a sign as standing for an object or idea outside itself, we don't produce a final meaning but a *text* which is always open to new readings.

I SEE LANGUAGE AS A 'SYSTEM OF SIGNS'. THE SIGN IS MADE UP OF TWO PARTS: THE SIGNIFIER, WHICH IS THE SOUND-IMAGE, AND THE SIGNIFIED, WHICH IS THE CONCEPT REFERRED TO.

FOR EXAMPLE, THE SOUNDS I UTTER WHEN I SAY 'TIGER' AND THE LETTERS I PUT DOWN ON PAPER THE WORD...

't-i-g-e-r'

...CONSTITUTE THE SIGNIFIER. THE CONCEPT OF A FOUR-LEGGED, FIERCE AND FURRY FELINE EVOKED BY THOSE SOUNDS OR LETTERS CONSTITUTES THE SIGNIFIED.

Saussure stressed that there is no natural connection between the *signifier* and the *signified*. The link is always *arbitrary* and *conventional*.

Language doesn't name universal concepts shared by all cultures. In fact, it creates its own categories, in order to make sense of the world according to different cultural circumstances.

They don't simply name universally-accepted concepts. They don't tell us what 'yellow', 'blue', 'red', etc. *are*. Colour terms are created within a specific culture in accordance with how that culture perceives the world. There is no exact correspondence, for instance, between English and Welsh colour terms.

English	Welsh
	gwyrdd
green	
blue	glas
grey	
brown	llwyd

Saussure also stressed that what makes a sign 'meaningful' is not some particular individual quality. Meaning is the product of a sign's 'difference' from and 'relation' to other signs. We can only understand signs in the context of other signs. This makes language something of a *game*. Saussure actually compared language to the game of chess: the pieces on the board don't mean anything outside the rules of the game. Each piece only acquires meaning in relation to all the other pieces and their moves. Similarly, each sign only acquires meaning in relation to all the other signs in a language.

In the context of visual language, Saussure's model can help us identify the various levels on which an image works. The image doesn't present us directly with concepts and meanings. It is primarily made up of *signifiers*, which we can link to certain ideas on the basis of the conventions of our culture.

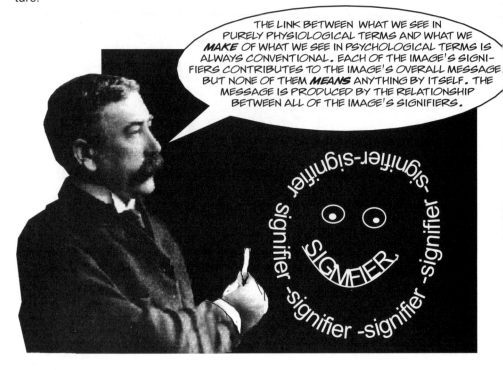

THE LINK BETWEEN WHAT WE SEE IN PURELY PHYSIOLOGICAL TERMS AND WHAT WE **MAKE** OF WHAT WE SEE IN PSYCHOLOGICAL TERMS IS ALWAYS CONVENTIONAL. EACH OF THE IMAGE'S SIGNIFIERS CONTRIBUTES TO THE IMAGE'S OVERALL MESSAGE BUT NONE OF THEM **MEANS** ANYTHING BY ITSELF. THE MESSAGE IS PRODUCED BY THE RELATIONSHIP BETWEEN ALL OF THE IMAGE'S SIGNIFIERS.

MEANING

MEANING

MEANING

MEANING

MEANING

Poststructuralism has taken Saussure's insights further. It argues that a signifier doesn't unproblematically lead to a signified - to *meaning*. In fact, we move incessantly from one signifier to the next. A signifier doesn't point to meaning. It is only a clue to various possible meanings. Take a simple example. Sometimes when we look up in the dictionary a word we don't know, we come across explanations of that word which contain other words we also don't know. And if we look these other words up, we may find yet more words we don't know. This is just a practical illustration of something which happens *whenever* we use language in its various forms.

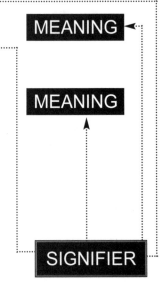

SIGNIFIER

Applied to the visual image, the poststructuralist approach entails a never-ending exchange between the image and the viewer. Even when we think we have 'understood' a picture, something slips out of our grasp.

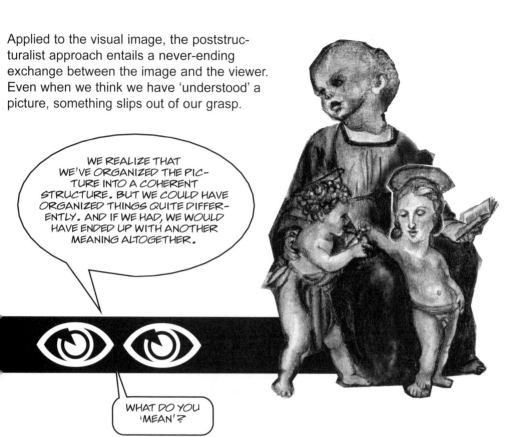

WE REALIZE THAT WE'VE ORGANIZED THE PICTURE INTO A COHERENT STRUCTURE. BUT WE COULD HAVE ORGANIZED THINGS QUITE DIFFERENTLY. AND IF WE HAD, WE WOULD HAVE ENDED UP WITH ANOTHER MEANING ALTOGETHER.

WHAT DO YOU 'MEAN'?

Looking at images is a private experience. We see things according to personal moods, states of mind, and feelings. Sometimes, *talking* about this experience is counterproductive. As we struggle to translate our responses into words, we find that something vital is lost.

But looking at images is also an experience we share with millions of other people - semiotics studies sign systems in relation to cultural codes and conventions. To this extent, it can help us grasp a common base-line for individual responses.

At this point you could be told: here's a reproduction of a famous painting, and here's how to read its signs. But this has been done often enough. There are plenty of detailed analyses of pictures. They are helpful but (for all the reasons given above) they can never be exhaustive. So, what follows is not a reading of a particular image, but rather a checklist of aspects of an image which the viewer can look for and explore. The list tries to stress that any aspect of an image can disclose further aspects which were perhaps not so obvious at first. Interpretation is inevitably an *incremental* process. Hopefully, you'll find time to extend the list yourself.

How the image engages the viewer's attention:

Rhythm
Prominence
Frame
Technical Devices
Narrative

How the image conveys information to the viewer:

Themes
Scenes and Portrayals
Actions and Events
Characters
Attributes

How the viewer sees the overall composition:

Lines
Position of Forms
Interplay
Contrast
Coherence

First of all, an image 'engages' the viewer. It draws her/him into its world.

Often, what first engages us is a sense of rhythm. This can be evoked by a number of different impressions: movement, harmony, conflict, etc. Figures, colours and shapes can be seen to 'work together' to convey a sense of balance or 'against one another' to convey a sense of *disharmony*. The rhythm of a picture can be gentle, graceful, dreamy, punchy, vigorous, aggressive, etc. (Think of different types of music and dance to help you describe to yourself the rhythm of a picture.)

Images also engage our interest by putting a shape, figure or colour in a special position. The prominence of a particular element in the picture's overall composition gives it the power to grab the viewer's attention. Many things can be used to guide the viewer's eyes: a patch of colour, a web of lines, a human body. A character can gain and hold our attention as an object of special interest by directing her/his gaze towards the viewer. Think of those slightly unsettling portraits where the sitter's eyes seem to be following you around the room.

Anything can be made prominent. But to make it prominent, the artist must frame it: s/he must give it a central role in relation to other elements. Consider again Saussure's idea that things are not meaningful by themselves: they only gain significance *in relation to other things*. In a picture, one element is significant if other elements help it become significant. In a religious painting, for instance, a holy character can be made prominent by a halo. In all sorts of pictures, a character can be made central by handling the scale of various other figures in relation to it. Our eyes are also engaged by means of technical devices. The ways in which **light**, **colour**, **line** and **perspective** are used guide our vision. They invite us to concentrate on certain aspects of the picture, and help us move from one component to another. Images often draw us into their worlds by telling a story. They give us a narrative. Unlike written texts, they don't unfold page after page. All the parts of the *plot* fill one single surface. And it's our task to connect them so that they tell a story.

Images also convey information to the viewer. This can be broken down into two main categories:

themes **scenes and portrayals**

'**Themes**' refers to the overall narrative presented by a picture. The theme may be religious, mythological, historical, domestic, etc. When a painting belongs to a tradition with which we are familiar, its themes are instantly recognizable (e.g. Madonna and Child). But there are times when a picture's narrative themes are more personal or unconventional. This is often the case with abstract art. It is then pretty much up to the viewer to identify and name them.

'**Scenes and portrayals**' refers to representations which don't involve any action: still-life pictures, landscapes, or portraits of people. But lack of action doesn't mean that these images don't tell a story.

A PORTRAIT, FOR EXAMPLE, CAN TELL A STORY ABOUT ITS SITTER AND THE SITTER'S WORLD THROUGH ITS USE OF OBJECTS, SYMBOLS AND **PROPS**, EVEN IF THE SITTER IS NOT OBVIOUSLY ENGAGED IN ANY ACTIVE TASKS.

Landscapes, for their part, can tell stories about aspects of the natural world they depict and about the artist's perception of that world. Sometimes it's useful to distinguish between actions and events. 'Actions' normally involve human beings. An action is what a character is *doing*. 'Events' normally describe natural phenomena which don't involve people. An event is what is *happening*. When people are involved in a picture, it's important to study them on two levels: as 'characters', and in terms of their 'attributes'. **Characters** are the people themselves, as defined by their bodies, their expressions, their gestures and attitudes. **Attributes** are the objects that accompany them, their clothes and other ornamental elements. It's often impossible to figure out a character independently of its attributes.

Working with an image's signs, the viewer grasps its overall composition. Certain aspects of the image make it cohere as one image. But this doesn't imply that the image ultimately *means* 'one' thing. When we pull together all the various bits and pieces listed above, we come up not with a final meaning but with a sense of how the picture *has been constructed*. In figuring this out, the viewer can take various structural aspects into account:

how lines are used to convey a sense of stillness or movement, restfulness or animation;

how the image's overall balance is achieved by the position of forms within the frame;

how these forms interplay with one another; and how this interplay manages to express a sense of coherence and harmony, or else a sense of contrast and discord.

THERE'S NO POINT IN TRYING TO FOLLOW THESE THREE STAGES CHRONOLOGICALLY. MUCH OF THE TIME, WE GET A GENERAL IMPRESSION OF AN IMAGE'S STRUCTURE WELL BEFORE WE HAVE GRASPED ITS INDIVIDUAL ELEMENTS.

And sometimes, an individual element can go on holding our attention even after we've recognized that it's part of a larger scheme. But hopefully, we'll be in a position to understand how many disparate concerns go into the making of any one picture.

Space and Perspective: Structure, Form and Meaning

We are often more familiar with the reputation of an artist than with the appearance of her/his work. The content and form of a picture are often subordinated to the painter's fame. And by and large, even when we think of actual pictures we are more likely to be concerned with their subject matter than with their form. Yet understanding a picture's composition is of crucial importance. It doesn't simply help us find out about the picture itself. It also tells us about the circumstances in which it was made.

Composition

Form is no less significant than content and can affect deeply our appreciation of an image. Some images rely heavily on ornamental detail, others on geometrical design stripped of decoration. Some convey ideas through simple lines, others work on the senses through spontaneous brush stroke. Some show neatly-bounded areas of paint, others offer surfaces on which paint has been dripped or smeared. These differences don't simply express personal preferences. They also tell us about what the painter's culture wished or expected to see; about the painter's tendency to conform with, or break away from, tradition; and about the strategies that can determine how an image will be viewed and interpreted.

Composition in a picture highlights the combination of various elements into a whole. The most common types of composition are:

> **symmetrical - asymmetrical**
> **enclosed - open**
> **unified - non-unified**

In 'symmetrical' composition, what is stressed is the balance of the elements. In 'asymmetrical' composition, shapes and colours are organized in a more irregular fashion. Symmetrical composition tends to convey a sense of order, asymmetrical composition a sense of energy.

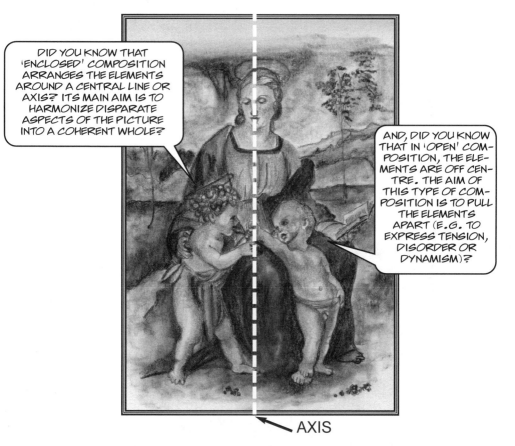

AXIS

In 'unified' composition, different elements interact within the frame of the picture to convey a sense of stability. In 'non-unified' composition, shapes and objects are treated more individually. Separate elements are more important than the overall effect.

Straight lines express stability and security;

Curves suggest instability, agitation and anguish;

Diagonal lines give energy and movement to a theme.

S-shaped lines can be employed to connect smoothly the various parts of an image, and impart a feeling of gentleness to the overall composition.

Different geometrical shapes can be used as the basis of a painting's structure.

Regular shapes emphasize order.

Irregular shapes suggest a sense of liveliness.

The circle focuses the picture's theme or action.

The triangle can be used to convey stability, especially if it's wide-based. But an inverted triangle suggests uncertainty.

The concept of _proportion_ is also very important. But it is by no means universal.

FOR EXAMPLE, IN TRYING TO FIGURE OUT THE BALANCE BETWEEN THE VARIOUS ELEMENTS OF THE HUMAN FORM (THE 'CANON'), ANCIENT EGYPTIAN ARTISTS TOOK THEIR MIDDLE FINGER AS THEIR BASIC UNIT, WHEREAS MOST WESTERN ARTISTS HAVE TAKEN THE HEAD AS THEIRS. THE EARLY RENAISSANCE THEORIST _LEON BATTISTA ALBERTI_ (1404–72) BELIEVED THAT A PERSON'S IDEAL HEIGHT SHOULD BE 7 1/2 TIMES THE HEIGHT OF HER/HIS HEAD. BUT I EXPERIMENTED WITH BODIES WITH A HEIGHT RATIO OF UP TO 9 OR 10 HEADS.

Albrecht Dürer (1471-1528)

Other 16th-century artists altered the ratio quite drastically to produce elongated figures which managed to look majestic but also rather vulnerable. These examples show that the tricks used to achieve certain compositional effects can be either fairly basic or very complex. But what matters most is that formal strategies change quite dramatically according to time and place. Alberti's 'solid' body was probably meant to convey the idea, popular in his society, that humans were the centre and measure of all things. The 'insecure' 16th-century body, on the other hand, expresses the anxieties of a far less self-confident society.

109

From Content to Form

Much of the time, we only look for content. We try to identify figures, casts of characters, plots and narratives. Naturalistic images generally encourage this type of reading. But the *formalism* of abstract art poses a different challenge.

Abstract art can be helpful in enhancing our understanding of all sorts of styles. In emphasizing form, it invites us to consider the compositional features of all images, not merely abstract ones. Of course not all pictures are abstract, but all pictures use technical instruments and methods. When their themes are instantly recognizable, we don't pay much attention to these formal aspects. But when we realize that pictures can be about form *before* saying anything about content, we also discover that any image should be appreciated not for what it 'is' but in terms of how it has been 'put together', or *structured*.

Shapes in Space

The **structure** of an image depends on its arrangement of shapes in space. There are many ways of positioning objects in relation to one another. Medieval artists followed two main rules: the central figures had to be placed in the upper part of the painting and had to be represented as larger than the lesser figures. God would certainly be more prominent than a saint or an angel, and humans would no doubt look puny by comparison with everyone else. These images emphasized the gulf between heavenly and earthly existence: they adopted a *theological perspective*.

THINGS CHANGED RADICALLY DURING THE RENAISSANCE, THE AGE OF *SCIENTIFIC PERSPECTIVE*. OBJECTS HAD TO BE LOGICALLY ARRANGED IN SPACE TO APPEAR AS THEY WOULD IN REALITY. THE IMAGE WAS STRUCTURED AS A SET OF CONVERGING LINES AND EACH ELEMENT MUST BE GIVEN ITS PROPER PLACE ON THIS GRID TO TAKE ON ITS CORRECT DIMENSIONS.

But perspective is not merely a device. It's also a science governed by strict mathematical principles. Its fundamental elements are the **ground line**, which normally coincides with the base of the picture, the **horizon line**, ideally placed at the same level as the painter's or viewer's eyes, and the **points of view**, which are placed on the horizon line. If the point of view on the horizon line is at the centre of the scene, we talk of 'central' perspective. All the lines converge on that point. Finding the point where all lines converge and focusing on it as the picture's pivot is supposed to help the viewer appreciate fully the artist's vision. The viewer must kind of *identify* with the painter.

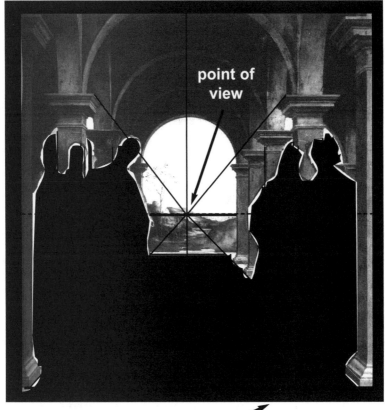

point of view

horizon line

ground line

The Italian architect **Filippo Brunelleschi** played a key role in the invention of scientific perspective.

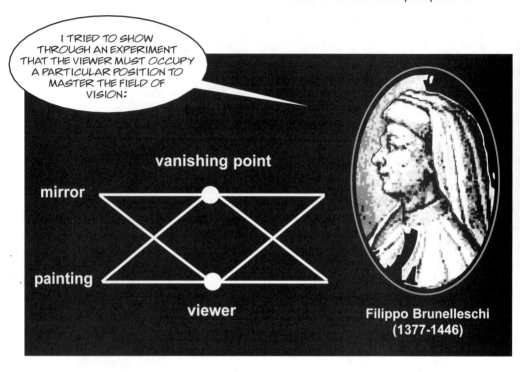

I TRIED TO SHOW THROUGH AN EXPERIMENT THAT THE VIEWER MUST OCCUPY A PARTICULAR POSITION TO MASTER THE FIELD OF VISION:

vanishing point

mirror

painting

viewer

Filippo Brunelleschi (1377-1446)

He placed a mirror in front of a painting and a viewer behind the painting. The viewer had to look at the painting's reflection in the mirror through a hole made in the canvas. This was supposed to be the *correct* position from which the painting must be viewed to grasp its use of perspective. The viewer's place was the equivalent of the 'vanishing point' in the picture: i.e. the point where all lines converge. It was a privileged place, the apex of the cone of vision. Just as the vanishing point is unique (for it's the only place where all lines meet), so the viewer's position is also supposed to be unique...

...FOR IT'S THE 'SPECIAL' PLACE FROM WHICH ALL THE PLANES OF THE IMAGE CAN BE DOMINATED.

Scientific perspective was also supported by mechanical and mathematical tools and devices. **Albrecht Dürer**, for example, used the *fixed viewfinder*, a mechanism which enabled him to look at an object through a lens, trace the object's outline, and then transfer it onto paper by means of a grid which cut the object up into squares.

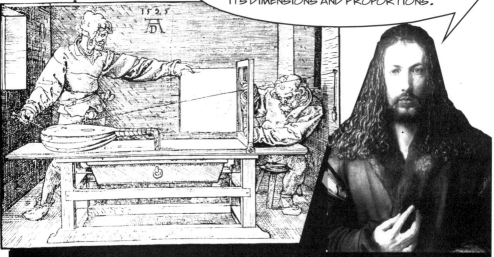

I ALSO USED THE *VIEWFINDER*, A SYSTEM WHICH ENABLED ME TO OBSERVE AN OBJECT THROUGH A LENS AND WORK OUT ITS DIMENSIONS AND PROPORTIONS.

Many artists, particularly landscape painters, used an optical device called a *camera obscura* which, with the aid of lenses and mirrors, was meant to help them record a view without distortion. The *camera obscura* is the forerunner of the modern photographic camera.

Technically, perspective is a way of creating the illusion of three-dimensionality on a two-dimensional surface. But ideologically it is a lot more than that. As Brunelleschi's experiment shows, it is a way of dictating a *correct* way of seeing. It is a way of nourishing the fantasy of the viewer as the *master* of vision. The viewer is defined as a privileged geometrical point in space upon which all the picture's lines converge. Perspective centres everything on the eye of the beholder: it enables him/her to play God.

The problem, of course, is that God is supposed to be everywhere and see everything at all times, while the human spectator can only be in one place at a time. Perspective, therefore, is not real mastery but an *illusion* of mastery. But illusions are ideologically very important. And this particular illusion is very much in keeping with the growing emphasis on the *individual* typical of the western Renaissance and with the entrepreneurial spirit of emerging capitalism. What we have here is a clear example of how certain representational techniques come about in response to a culture's ideological requirements. Ways of representing space reflect not space itself but cultural perceptions of it. These are often arbitrary and illusory, even when they are committed to the highest degree of naturalism.

In the 16th and 17th centuries, artists became increasingly aware of the fact that perspective plays with illusion. They used geometrical rules to create optical tricks. Many Baroque vaults, for example, show hugely foreshortened figures which give the illusion of a deep field of vision. But if we were to look at any of these figures closely and separately, it would look totally unreal. If scientific perspective in the early Renaissance was meant to make things appear absolutely real, this *perspective of illusion* uses mathematical principles to *distort* reality in often flamboyant ways.

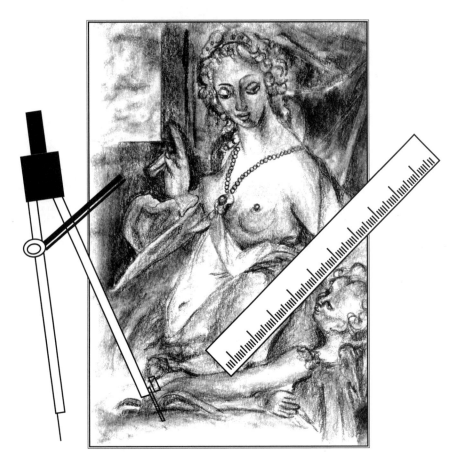

The type of perspective studied by Brunelleschi (amongst others) is often referred to as 'linear' perspective. In 'colour' perspective, the illusion of space is conveyed by using lighter colours towards the back of the image. This system was preferred by Venetian painters of the Renaissance. In 'atmospheric' or 'aerial' perspective, the illusion of space is created through the modulation of colour. Bright colours represent images close to the picture's foreground, and faint ones represent distant landscapes. In 'flat' perspective, the various elements of an image are juxtaposed.

Materials and Techniques

A work of art isn't just a manifestation of the artist's mind. To produce a work of art, any artist must rely on something fundamentally *material* - paint, wax, metal, glass, etc. The study of various materials and techniques is a means of grasping the *physical* side of art and art-making.

Art in Practice

Practically anything can be used as a support for painting: walls, wood, canvas, paper, glass, marble, copper, slate, ivory, sheepskin, velvet, silk, satin, plastic, and the human body itself. From the art of ancient Egypt to the Renaissance, the most widely-used supports were walls and wood. Paintings on wood can be traced back to the Egyptians, the Greeks and the Romans. Mural paintings from Minoan, Etruscan, Egyptian, Greek and Roman art have survived almost intact through the centuries. Mural painting became especially popular in the Middle Ages, when the uneducated masses would learn the Christian story from pictures on church walls. In the Renaissance, murals were still used as a narrative form. Think of Michelangelo's highly complex narrative, depicted on the walls and ceiling of the Sistine Chapel.

In the Baroque period, the story-telling element of mural painting was supplanted by the ornamental function. The walls and ceilings of most churches and patrician buildings of the period were covered with intricate decorative motifs. Canvas gradually replaced wood and walls during the Renaissance. But we can find the ancestor of canvas painting in ancient Egypt. Egyptian art is instantly associated with wall paintings and richly-decorated wooden coffins. But between the 8th and the 6th centuries BC, it became common practice to wrap the coffin in a linen cloth, decorated with divine images and ceremonial symbols. People believed that the dead couldn't rest until the painting of the cloth had been completed. God knows how the dead must have felt when archaeologists started raiding the ancient tombs and tearing the painted cloths open!

Cave painters

used five main **pigments** (i.e. colouring materials): iron to produce red, manganese to produce black, charcoal, casein (made from sour milk) and blood. These were mixed with animal fat.

The ancient Egyptians, Greeks and Romans

used three main techniques: **tempera,** where the pigments are mixed with water, the whites and the yolks of eggs, and gluey substances; **fresco,** where water-soluble pigments are applied to a surface of wet plaster (large fresco paintings are divided into several areas, a bit like a jigsaw puzzle); **Encaustic painting,**

Light Blue

where either pigments dissolved in wax are applied to a surface when they are still hot, or else the painted surface is glossed with a layer of melted wax. Tempera was the dominant technique up to the end of the 15th century, when it started giving way to **oil.** Here the pigments are mixed with oil (usually linseed or walnut) to produce shimmering lights and tactile textures.

Watercolour

uses pigments held together by gums and thinned with water. In **gouache,** coloured pigments are mixed with water, as in watercolour, but with the addition of the white pigment, which gives the paint an opaque effect.

In sgraffito

a layer of coloured plaster is covered with thin layers of white plaster; lines are then drawn into the top coat with a sharp blade to reveal the underlying colour.

Pastel

is a dry technique in which ground pigments, mixed with an adhesive, are shaped into sticks. It was particularly popular in the 18th century.

Wax

is based on similar principles but it produces greasier effects because the pigments are mixed with wax and other meltable substances.

All techniques have specific qualities and advantages. Tempera has luminous qualities and is well-suited to the production of illusionistic effects. Fresco lends itself ideally to precise line work. Pastel has a distinctive velvety texture. Watercolour can convey a sense of freshness and spontaneity. And so on. But different techniques are also closely associated with specific cultural contexts, historical periods, fashions and tastes. When we have figured out what technique has been used to execute a work of art, we should ask ourselves: what particular effects was the artist hoping to produce by using *this* technique? was s/he following an established trend or was s/he experimenting with new media?

An image is never simply the embodiment of an idea but actually a material object produced through the manipulation of particular materials. Sometimes artists trust their flair, rely on sustained practice and experimentation, or even abandon themselves to the possibility of 'accidents'.

At other times, they abide by strict technical guidelines. In either case, we must recognize what specific effects can be achieved through specific materials, for different media correspond to different *ideologies*. For example, the triumph of *oil painting* in the Renaissance corresponds to a desire to render material objects in all their lustrous richness of colour and texture. This medium lends itself ideally to the representation of solidity. It was therefore particularly suitable to the aims and interests of the rising mercantile classes and of affluent patrons, who wanted pictures to represent as tangibly as possible their prosperity and status. The objects represented in those paintings appeared solid and substantial, as things which could be touched and, above all, *owned*.

A Mini-Gallery

This is a necessarily selective and limited survey of some of the techniques used by 'famous' modern artists.

Please bear in mind the following points:

 the 14 painters listed below are not supposed to be more important than any others: they are only meant as illustrations;

 the techniques associated with each painter are not the only ones used by that painter: they are simply representative;

 the painters are listed in *alphabetical* order to avoid hierarchical classifications!

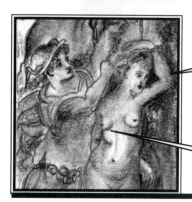

A GAME FOR YOU TO PLAY:

SEE HOW MANY OF THESE TECHNIQUES (AND ARTISTS) YOU CAN SPOT IN ANY NUMBER OF GALLERIES AND BOOKS AT YOUR DISPOSAL, THEN THINK HOW EACH 'WORKS' FOR YOU.

UMBERTO BOCCIONI (1882-1916)

How does a static picture capture the sensation of *speed*? When something moves at great speed before our eyes, it seems to dissolve. Boccioni tried to convey this impression by fragmenting forms into small facets which seem to stretch and spread over the canvas.

MARC CHAGALL (1887-1985)

Visual images don't have to show a distinct moment in time. They can thrive on *simultaneity* and bring together disparate scenes from reality. And these don't have to be connected by scientific principles (e.g. perspective) or narrative rules (e.g. beginning, middle and end). They can be simply *juxtaposed*. Chagall often bridged separate areas of a picture by means of 'floating' figures that defy the law of gravity.

SALVADOR DALI (1904-1989)

Various techniques can be used to express unconscious fantasies and fears. The fluidity of dream-images, for example, is suggested by Dali through the transformation of hard objects into soft, 'cheese-like' shapes (e.g. melting clocks). Another example is the use of the same basic shape in different parts of a painting to symbolize different objects. An oval can be used to represent a human head and then be repeated elsewhere in the picture to represent an egg.

GEORGE GROSZ (1893-1959)

If an artist wishes to convey a sense of depravity, a technique available to him/her is *satire*. Grosz expresses moral ugliness through physical ugliness: grotesque bodies, bloated faces, tarty clothes and make-up. Vignettes drawn from city life evoke speed and excitement. But gross attitudes and lurid colours suggest that beneath the gloss there are hypocrisy and greed.

WASSILY KANDINSKY (1866-1944)

An image can be based on the formal arrangement of geometrical shapes. Each shape has symbolic significance. The circle is the most intriguing for Kandinsky because it combines stability and instability, stillness and movement, silence and sound. The same picture sometimes depicts *quiet* bubbles and *noisy* sun-like rings. Colour and line should convey harmonies and rhythms comparable to those expressed by music.

PAUL KLEE (1879-1940)

Line isn't just a 'tool'. It can depict feelings, moods and thoughts. (Cartoonists, for example, often crystallize ideas in just a few concise marks.) In Klee's paintings, line is used to convey a wide range of expressions. A single line can suggest a grin, a smile, a crooked eye, the raising of an eyebrow. And any expression can evoke - through that line - joy, pain, sarcasm, despair, etc. The various lines used in a picture to describe people, animals, landscapes, etc. are all *equally* important. Nothing is presented as a privileged focus of attention. Nature is in constant flux and all things are interconnected.

GUSTAV KLIMT (1862-1918)

The 'fine' arts and the 'decorative' arts are not always as neatly separated as traditional art criticism would have us believe. Klimt's pictures often look like ornamental objects, embroidered cloth or jewels. But beneath the surface lies a complex content which, because of its intensely erotic nature, was found very disturbing by many of his contemporaries. Content can't be put across without appropriate techniques. It's not simply a matter of 'themes' relating to sex, death, ecstasy and seduction. The effectiveness and original handling of these ideas are inseparable from the artist's deep concern with materials (gold, silver, gems), textures, sinuous lines and spiralling patterns.

120

KASIMIR MALEVICH (1878-1935)

The 'Suprematist' technique used by this artist is a radical way of giving up the realistic representation of the world. Paintings are constructed out of basic geometrical shapes: the square, the triangle, the circle, the cross. They use a deliberately narrow range of colour: mainly black, red, yellow and blue. And they make no attempt to represent three-dimensional space. But these simplified forms often suggest a great sense of movement, falling figures, and comets racing through space.

FRANZ MARC (1880-1916)

Stylized images of animals, especially horses, are used by Marc to symbolize natural and instinctual life and an existence at one with the environment - or else chaos and terror. It's not the animals themselves that convey these feelings. Certain compositional techniques must be used. For example, a group of blue horses arching their necks in a spirited way suggests energy and freedom. But the clash of red and black animal forms evokes violence and fury. Colour and line are vital to the overall effect.

HENRI MATISSE (1869-1954)

Colour isn't a way of describing objects. It has expressive and emotional powers of its own. A colour can 'flood' a whole scene to convey stillness, energy, joy, fear, etc. It doesn't have to be restricted to specific shapes. For example, a scene taken over by 'blue' can express tranquillity. And the force of the main colour can be intensified by occasional patches of complementary ochre.

JOAN MIRÓ (1893-1983)

Placing side by side bold areas of colour, delicate lines, amoeba-like shapes trailing across the void, and ornate calligraphy, Miró was able to *rethink* the idea of space. Traditionally, western painting aims at creating an illusion of depth through mathematical rules or the use of colour. But an alternative sense of space can be created by the juxtaposition of lines, shapes and colours on a surface which is flat, and is not *trying* to look three-dimensional. A limited impression of depth makes Miró's two-dimensional space a space *in its own right*.

EDVARD MUNCH (1863-1944)

Can intimate feelings be given visible form? All sorts of styles have tried to tackle this question. There is no single satisfying answer, of course. One of Munch's techniques was to use lines of colour to express moods and emotions. Undulating lines, often painted in unusual combinations of hues, suggest a flowing and dreamy world which, however, turns out to be illusory: the figures that inhabit it are scared, lonely and sick. Colour and line transform the dream into a nightmare.

PABLO PICASSO (1881-1973)

Sometimes art is at its most experimental when it doesn't just *reject* tradition but rather *reworks* it. Pictorial space is under no obligation to imitate the real world (whatever that is!). It can collect elements from both reality and the conventions of traditional painting and then reassemble them in unexpected, comical or disturbing ways. The beauty and gracefulness of Classical figures can be 'reinterpreted' to produce distorted, frenzied or cartoon-like characters. Several views of a single human body or object can coexist in one image. Violence, fear and confusion can be conveyed by jagged lines and stark colour contrasts; peacefulness by arcs and circles, and harmonious colour schemes.

Abstraction allows the artist to explore in depth the interrelation of line, colour and light. Riley organizes basic shapes - such as circles, triangles, straight, zig-zag or wavy lines - into repeating 'bands' which give off the subtle changes of light. Images of torrents, ripples and flickering shadows are often evoked by these images. Some of Riley's most famous paintings use a wave-like rhythm which gives both a sense of relaxation and an impression of vibrating tension. Often, they produce optical disturbance and physical disorientation. When colours are used, the contrast between the warm glow of red and the cold luminosity of blue and green conveys a strong feeling of movement.

Material Worlds

The study of artistic techniques and materials can be a means of understanding broad processes of perception and knowledge. As we saw in the first section, perception is a complex issue. It has to do with how we feel, how we think, how we get to know things, and how we communicate knowledge. The ways in which artists respond to the problem of perception through particular techniques and materials is a kind of *metaphor* for the ways in which all people try to make sense of what they see. Exploring the issue of perception is not just a game for experts to play. It's something we are all involved in (consciously or unconsciously). And it's something we pursue not only through our minds but also through our *bodies*.

Aesthetics (as the discipline concerned with how we relate to artworks) has often served the interests of particular cultural elites, keen on demonstrating their intellectual superiority and on devaluing the body and the senses. But when we look at art from the point of view of practical techniques and materials, it isn't possible to think in purely abstract terms, such as vague notions of artistic *value*, *creativity*, or *connoisseurship*.

The study of the material side of art brings the body back into play. Materiality is central to all art, because artworks are physical objects, constructed through physical practices. Pictures are bodies, they are created by bodies, and we respond to them largely through our bodies. All the senses have a part in this process, not just sight.

Touch, smell, hearing and taste contribute to both the artist's and the viewer's experience of pictures. For example, pictures are often extremely tactile. Sometimes the things they represent look so solid we feel we could actually hold them in our hands. At other times, they appeal to the sense of touch through their textures: smoothness, roughness, crevices, ridges, knots, swirls, etc. A picture's texture can also appeal to the sense of taste: it can look 'creamy', for example, or evoke the image of icing on a cake.

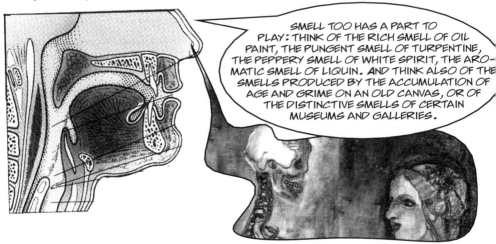

SMELL TOO HAS A PART TO PLAY: THINK OF THE RICH SMELL OF OIL PAINT, THE PUNGENT SMELL OF TURPENTINE, THE PEPPERY SMELL OF WHITE SPIRIT, THE AROMATIC SMELL OF LIQUIN. AND THINK ALSO OF THE SMELLS PRODUCED BY THE ACCUMULATION OF AGE AND GRIME ON AN OLD CANVAS, OR OF THE DISTINCTIVE SMELLS OF CERTAIN MUSEUMS AND GALLERIES.

Hearing has been a vital source of inspiration for a number of abstract painters. **Wassily Kandinsky** (1866-1944), in particular, was guided by his love of music. He wanted colour and line to express harmonies and dissonances analogous to those produced by sounds. **Paul Klee** (1879-1940) wished to find pictorial expression for two musical concepts: *polyphony* (many voices) and *counterpoint* (the combination of different melodies). To achieve this, he used contrasting shapes and hues which played off against each other in the overall harmony of the image.

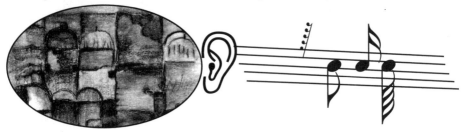

These examples show that the experience offered by images is not always purely visual. It can also be tactile, gustatory, olfactory and auditory. The *material world* of the image is a world of sensuous pleasure.

In the course of the 20th century, the visual image has been deeply affected by the rapid development of new media and technologies. But its materiality hasn't disappeared. In some cases, in fact, it has increased.

Some artists have emphasized the image's material character by placing pictures in a *total environment*. Painting, for these artists, isn't an isolated art but takes place in a wide range of practices.

TOM WESSELMAN (B.1931), FOR EXAMPLE, CREATED MIXED MEDIA TABLEAUX IN WHICH PAINTINGS (E.G. HIS FAMOUS 'GREAT AMERICAN NUDES') ARE SURROUNDED BY FURNITURE, DECORATIVE OBJECTS AND PROPS. IN SOME CASES, THE TABLEAUX ALSO CONTAINED AURAL EFFECTS: TAPED SOUNDS, RADIOS, AND TELEPHONES RINGING INTERMITTENTLY. THESE TECHNIQUES STRESS THE MATERIALITY OF IMAGES BY RELATING THEM TO A VARIETY OF THREE-DIMENSIONAL OBJECTS.

Another way of emphasizing a picture's materiality is to relate it to its physical surroundings. One of the most interesting works produced by **Louise Lawler** (b.1947), for example, is a photograph showing the reflection of a painting by **Frank Stella** (b.1936) on a gallery's highly-polished floor. This technique shows that a work and its context are indissolubly connected. The painting by Stella is fundamentally a material object, interacting with the material world of the gallery. **Barnett Newman** (1905-70) stressed the relationship between paintings and their physical environment in a different way. He created huge red expanses (nearly twenty feet in length) which couldn't possibly be absorbed as *whole* pictures. These paintings created an overpowering environment of colour for their viewers. They were not something to be simply 'looked at' but rather something to be *inhabited*.

The materiality of visual images can also be expressed by using the human body as an 'image'. For example, Adrian Piper (b.1948) has used her body as a living picture to make statements about sexuality, race, and her own experience as a black woman. In her Performance work, she has emphasized the complexity of cultural identity by adopting a deliberately ambiguous image: white face make-up, pencilled-on moustache, Afro hair and mirror shades.

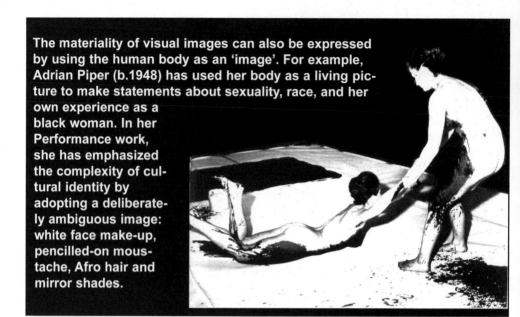

Piero Manzoni (1933-63) used his own body and other people's bodies in a number of ways. He made a model into a work of art by putting his signature on her flesh. He canned his excrement and offered it for sale. And he created a work called *The Artist's Breath* (1961) by simply inflating a balloon.

Artist's excrement
$120,000,000,000

The Performance artist **Vito Acconci** (b.1940) used his body as an image through simple pieces, or 'activities'. In *Rubbing Piece* (1970), he rubbed a spot on his arm to produce a sore. In *Waterways* (1971), he filled his mouth with saliva until he couldn't contain it and had to spill it into his hands. In *Trappings* (1971), he spent three hours in a closet dressing up his penis in doll's clothes and talking to it as a playmate. As images, these Performance pieces emphasize that *all* images are basically material bodies. Bodies can become images because images themselves are bodies.

Colour and Culture

Colour plays a vital role as a cultural function. People have not always perceived colour the way we do now. And even today, not all societies see the world in the same colours. Nor do they have exact equivalents in their various languages to name different colours. There are many ways of thinking about colour in relation to images: as a visual stimulus, as incorporeal light, as a material substance. And it is often hard to tell where one colour 'begins' and another 'ends'. Perhaps this difficulty is helpful: it serves to remind us that we can never be sure where anything - our minds, bodies, ideas, desires - begins or ends. Art unrelentingly gives form to this uncertainty.

Colour in Theory

Funnily enough, black-and-white can be an ideal medium for a discussion of colour because it enables readers to use their own imagination.

If I talk of the properties of 'red', for example, and complement the written text with a patch of red to illustrate my point, I risk disappointing the reader who has visualized a completely different shade of red in her/his mind's eye. A black-and-white text doesn't have this drawback. And it has the advantage of allowing the reader to play an *active* role as an interpreter.

HUE	the actual 'colour'.
VALUE	degree of lightness or darkness.
INTENSITY	degree of brightness or dullness.
TINT	a hue lightened by white.
SHADE	a hue darkened by black.
MUTE	a hue mixed with grey.
FULL CHROMA	a pure colour.
LOW CHROMA	grey with just a tint of the pure colour.

PRIMARY COLOURS

red
blue
yellow

these are pure colours that cannot be made by mixing other colours together.

SECONDARY COLOURS

orange
violet
green

these are made by mixing two primaries together: orange = red + yellow; violet = blue + red; green = yellow + blue. Grey is made by mixing all three primaries together.

COMPLEMENTARY COLOURS

Each secondary colour is the complementary of the primary colour *not* used to make it; violet is the complementary of yellow, green of red, and orange of blue. Complementary colours are 'optical opposites'. Test this yourself through a simple experiment.

Draw a square and a smaller square inside it. Place a dot in the centre of the smaller square. Colour the central square in red and the surrounding area in green. Fix your eyes on the black dot inside the red square for at least a minute. Then shut your eyes tightly. An afterimage will appear: you'll see a green square inside a red one.

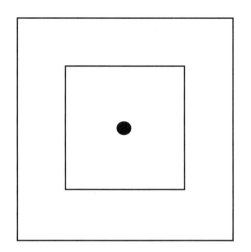

THIS KIND OF EXPERIMENT SHOWS THAT THE EFFECTS OF COLOUR ON US ARE OFTEN PHYSICAL, NOT PURELY INTELLECTUAL. ARTISTS CAN USE ALL SORTS OF 'TRICKS' - SUCH AS THE JUXTAPOSITION OF COMPLEMENTARY HUES - TO APPEAL TO OUR SENSES.

TERTIARY COLOURS	red - orange red - violet blue - violet blue - green yellow - green yellow - orange	These are made by mixing equal parts of a primary colour and its neighbouring secondary colour
WARM COLOURS	red and orange	
COOL COLOURS	blue and green	
	yellow and violet	(They can be warm or cool, depending on the balance of the component colours.)
NEUTRAL COLOURS	black and white	

Colours that are close together are *related*, or *harmonious*, and when they are used in the same picture they create a sense of calm, restfulness and balance. The combination of *complementary*, or *opposite*, colours, on the other hand, produces a contrasting scheme, which can be lively, vibrant and even aggressive. When different values and intensities of the same colour are put together, the result is a *monochromatic* scheme.

129

All colours have intrinsic qualities. Blue and green, and greys tinted with those two hues create a quiet atmosphere. Cool colours visually recede and can make objects appear larger than they really are (especially in pale tints). Red, pink, yellow, orange, and neutrals containing them evoke warmth. Warm colours advance and bring surfaces closer to the eye.

A BIT *TOO* CLOSE FOR COMFORT!

Colours can also be understood in relation to natural forms in the animal, vegetable and mineral realms. We often find colour terms such as 'chamois', 'teal', 'aubergine', 'rowan', 'tobacco', 'ebony'. More specifically, colours can be named by reference to the four elements: air ('breeze', 'sea-mist', 'sky'); water ('ultramarine', 'ocean', 'aquamarine'); earth ('terracotta', 'slate', 'lapis'); fire ('flame', 'sunshine', 'ruby'). There are also ways of describing hues in terms of light: e.g. 'dawn', 'twilight', 'moonlight'. At other times, colours are associated not with nature but with a particular period or style (e.g. 'Georgian blue').

Georgian Blue

Colour has interested philosophers throughout the ages. As early as the 5th century BC, the Greek philosopher **Empedocles** compared the artist's mixing of colours to the harmony of the elements (air, fire, water, and earth). In the same period, **Democritus** associated different colours with properties of the material world. For example, white stood for smoothness, black for roughness, and red for heat.

WHITE

BLACK

ANCIENT PHILOSOPHERS WERE ALSO AWARE THAT THERE IS AN INDISSOLUBLE LINK BETWEEN COLOUR AND LIGHT. *ARISTOTLE*, FOR EXAMPLE, SAW THE VARIOUS COLOURS AS MIXTURES OF VARYING PROPORTIONS OF LIGHT AND DARKNESS, WITH WHITE AND BLACK AT THE TWO OPPOSITE ENDS OF THE SPECTRUM.

Throughout Antiquity, purple held a special fascination for artists and thinkers because it was seen as the colour that could incorporate - miraculously - darkness and light, the qualities of night infused with the brilliance of the sun.

Philosophers were often troubled by the association between colour and light, because they realized that just as light changes constantly, so does colour. There are times when colours can't be exactly identified and named because they keep changing according to the play of light. Think of the astonishing range of hues that appear on certain birds'

I THINK I NEED SUNGLASSES!

plumage in sunlight. The difficulty in defining colours was taken by many philosophers as evidence for the eye's incapacity to tell the true from the false. Colour was therefore regarded as something *unreliable*. As a result, the ancients were rather ambivalent in their responses to the use of colour in painting. They thought that colour gave a painting life. But they also marginalized it as something purely decorative, and inferior to an image's use of line and rhythm. Two of the main Roman theorists of art, **Pliny** and **Vitruvius**, were very unhappy about the use of *polychromy* (many colours), which they deemed extravagant.

A problem for us is that we don't really know much about the impact of Classical theories on actual artistic practice, because hardly any specimens of Classical painting have come down to us. Modern perceptions of Antique art have also been based on gross misunderstandings of where colour goes. For example, it wasn't until the 19th century that archaeological evidence showed that Greek sculpture was lavishly coloured. This came as a shock to a long tradition of art criticism which had regarded the smooth white-ness of Greek statues and friezes as their most characteristic attribute. And it also affected deeply Neo-Classical artists, such as **Ingres** and **Alma-Tadema**, who started depicting vividly polychromed Greek interiors and reliefs as backdrops for their pictures.

WRITING IN *1623*, I SAID THAT THE PRIMARY QUALITIES OF AN OBJECT ARE ITS SHAPE AND SUBSTANCE. ITS COLOUR, TASTE AND SMELL ARE FAIRLY UNIMPORTANT, AS OUR PERCEPTION OF THEM IS SUBJECTIVE AND UNRELIABLE.

Galileo (1564-1642)

John Locke (1632-1704) argued that an object's primary characteristics are mass and hardness, and that these 'exist' independently of people's minds. Colours, by contrast, are secondary characteristics created by the mind. The perception of colours is affected by all sorts of physical factors - e.g. haze, fever, inebriation.

In his treatise on *Opticks* (1704), **Isaac Newton** (1642-1727) made a similar point:

THE SCIENTIST AND THE PHILOSOPHER SHOULDN'T WASTE TIME STUDYING COLOURS, WHICH ARE JUST ACCIDENTS OF LIGHT AND THE CONCERN OF 'COMMON' PEOPLE. RED LIGHT, FOR EXAMPLE, IS NOT IN ITSELF RED. IT IS THE EFFECT OF LIGHT RAYS WHICH STIR UP THE SENSATION OF THAT COLOUR. THERE'S NOTHING OBJECTIVE ABOUT WHAT WE MAY CALL 'RED LIGHT'.

Newton argued that there was no set of primary hues, and that all rays of refracted light were primary, or 'simple'. Newton's theories were meant to bring order into the puzzling world of colour. But developments in painting since Newton have shown that the study and use of colour can never be absolutely ruled by scientific laws.

> I THINK THAT THE EYE IS THE TOOL TO BE RELIED UPON IN THE STUDY OF COLOUR. I CARRIED OUT PRACTICAL EXPERIMENTS TO THIS EFFECT.

Goethe observed that the eye looks for harmony, and is capable of compensating for a strong stimulus induced by one colour by creating a complementary colour as an after-image.

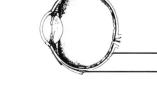

> I ALSO BELIEVE THAT LIGHT IS UNIFORM AND PRODUCES COLOUR ONLY WHEN DARKNESS INTERFERES WITH IT. NEWTON SAW COLOUR AS A PRODUCT OF CHANGING LIGHT. I SAY THAT LIGHT ITSELF IS POWERLESS UNLESS IT'S DISTURBED BY DARKNESS.

From a scientific point of view, Goethe may have been wrong. But he brought to the fore the viewer's creative faculties in ways which have proved very significant to the development of modern art.

In his *Critique of Judgment* (1790), **Immanuel Kant** (1724-1804) stated that what makes an object beautiful is its design, not its colours. Kant had little time for sensuous experience.

> I VALUE WHAT IS OBJECTIVELY 'BEAUTIFUL', NOT WHAT IS SUBJECTIVELY 'AGREEABLE'. COLOURS MAY BE CHARMING BUT THEY SHOULDN'T AFFECT OUR AESTHETIC JUDGE-MENT. THE APPRECIATION OF COLOUR IS PURELY SUBJECTIVE. COLOURS DON'T GIVE US AN OBJECTIVE TRUTH AND SO CAN'T BE BEAU-TIFUL. SAYING THAT A COLOUR IS BEAUTIFUL WOULD BE AS INACCURATE AS SAYING THAT THE TASTE OF A WINE IS BEAUTIFUL.

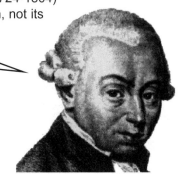

In his *Aesthetics*, **Georg Wilhelm Friedrich Hegel** (1770-1831) argued the oppo-site. He talked of colouring as a form of *magic*: brilliance, light, lusciousness, clarity, the fusion of hues and the play of reflections are vital aspects of painting. But Hegel didn't value the artwork's sensuous qualities as an end in themselves. He empha-sized that the viewer must be able to move beyond an object's material nature and see it as a universal idea.

Cultural and Symbolic Variations

People perceive colours differently. Some have astonishing colour vision, others are colour-blind (i.e. they can't tell red from green). It's sometimes argued that women's colour vision is more developed than men's, and that children's sense of colour develops gradually. It's most likely that no two painters will prepare exactly the same colour. Personal tastes and different feelings about hues will necessarily enter their practices. An artist's palette is a highly individual product.

With these words of praise, **Kandinsky** suggested that we may learn more about an artist's attitude to colour by studying his/her palette than the actual canvases.

PRAISE BE TO THE PALETTE FOR THE DELIGHTS IT OFFERS

IT IS ITSELF A 'WORK', MORE BEAUTIFUL, INDEED, THAN MANY A WORK.

WASSILY KANDINSKY
(1866-1944)

Palettes are artworks in their own right. Yet, it was only in the 18th century that the idea of a palette arrangement that could be as personal as style came to be accepted. And still now, plenty of books instruct students and amateurs to place pigments on a palette in a 'correct' sequence. (You soon give up, when you realize that some of the pigments you've squeezed out according to the instructions have remained untouched in the course of your painting, while other tubes have been returned to several times.) In 1878, **Camille Pissarro** actually made a landscape painting out of a palette with pure white, yellow, red, purple, blue and green on it.

People's sense of reality changes incessantly. Ways of perceiving colour change too. There is always a gap between material pigments and abstract colour terms. If I use the word 'blue', for example, what will you visualize? Ultramarine, Indigo, Cobalt, Prussian, Phthalo, Lapis Lazuli?

ULTRAMARINE OF COURSE!

I'D SAY 'SAD'.

The colours we see today are not the same as the ones perceived by our ancestors. The Romans were particularly sensitive to black and white.

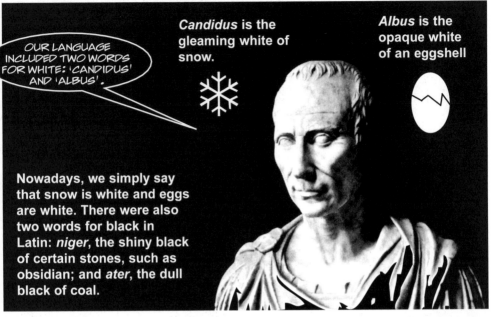

OUR LANGUAGE INCLUDED TWO WORDS FOR WHITE: 'CANDIDUS' AND 'ALBUS'.

***Candidus* is the gleaming white of snow.**

***Albus* is the opaque white of an eggshell**

Nowadays, we simply say that snow is white and eggs are white. There were also two words for black in Latin: *niger*, the shiny black of certain stones, such as obsidian; and *ater*, the dull black of coal.

The Greeks, for their part, didn't distinguish between green and blue. Green was seen as a shade of blue. The Latin word *rufus* covered everything from purple to gold, whereas Greek had four terms (*xanthos*, *eruthros*, *purros* and *kirros*) to cover the same area.

Sometimes colour terms result from a shift from the material to the abstract.

THE WORD 'PURPURA' (PURPLE) DESIGNATED A SILK FABRIC UNTIL THE RENAISSANCE, WHEN IT CAME TO MEAN A HUE.

'Scarlet' was originally the name of an expensive woollen cloth. Colours are embedded in the material values of a specific culture. They're attached to particular objects before they are used as broad labels.

The reasons why people perceive - or don't perceive - colours are not physiological. They are cultural. Consider a simple example: the use of colours in fashion. The colours of the clothes which people wore just ten or twenty years ago often look disconcerting to us, because our sense of colour (or *chromatic sensibility*) has altered.

Similarly, the association of black clothes with style, elegance and high society was first made in the 16th century. Up until then, black clothes were the garments of the poor and the dispossessed. The rich indulged in extravagant polychromatic clothing, such as 'lyotards' with legs of different colours. Changes in fashion are purely cultural phenomena. Take another example: lilac doesn't occur in painting before 1875. It makes its first appearance with the Impressionists, especially Monet and Renoir.

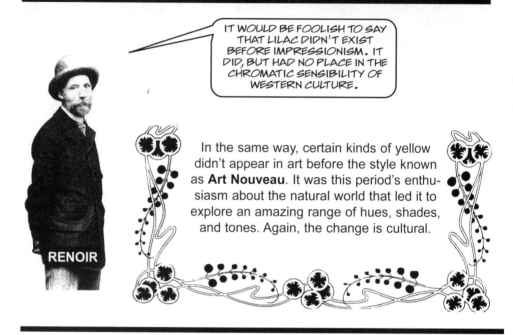

IT WOULD BE FOOLISH TO SAY THAT LILAC DIDN'T EXIST BEFORE IMPRESSIONISM. IT DID, BUT HAD NO PLACE IN THE CHROMATIC SENSIBILITY OF WESTERN CULTURE.

RENOIR

In the same way, certain kinds of yellow didn't appear in art before the style known as **Art Nouveau**. It was this period's enthusiasm about the natural world that led it to explore an amazing range of hues, shades, and tones. Again, the change is cultural.

The **Impressionists** saw colour as a fundamental part of painting. They excluded black as the non-colour. The **Expressionists**, conversely, used black profusely as a means of conveying symbolically feelings of sadness and distress. Black is a visual sensation associated with lack of light. But it's not the *absence* of visual sensation. We *do* experience it as a colour, i.e. as 'something' in our visual field rather than as 'nothing'.

Colours often carry symbolic connotations. This is largely because colours have a direct impact on our feelings and moods. They have the power to excite and to soothe, to uplift and to sadden us. Let's look at a few of the most popular interpretations of colours as symbolic forces:

GOLD	The sun, majesty, divinity, truth, reason, immortality.
BLUE	The intellect, peace, contemplation, faith, love, infinity.
RED	Energy, emotion, violence, war, masculinity, passion.
GREEN	Sensations, nature, growth, decay, jealousy, bliss.
BLACK	Death, sorrow, the underworld, time, rebirth, resurrection.
WHITE	Purity, virginity, transcendence, truth, death, mourning.
VIOLET	Power, authority, sanctity, wisdom, sorrow, mourning.
YELLOW	Faithlessness, betrayal, disease, humility, power.

As you can see, the same colour can hold conflicting meanings.

RED	alludes to energy both as a productive and as a destructive force.
GREEN	is ambivalent because it has both positive and negative connotations (e.g. growth/decay).
BLACK	is a negative colour in the west, but for the Egyptians it meant a new beginning.
WHITE	is equivocal because it symbolizes at the same time the purity of the soul and the pallor of death.
VIOLET	is a symbol of mystical power but is also associated with sorrow.
YELLOW	has plenty of negative attributes in the west, but in China and India it has political and religious importance.

These ambiguities are important because they show that there isn't a _universal_ perception and understanding of colours throughout the world. The symbolic import of colours changes from culture to culture.

Colour's symbolic connotations have often been highlighted by occult systems such as alchemy, magic, astrology and number symbolism. In the Middle Ages and in the Renaissance, these various systems were often brought together by heraldry. Heraldry used colour in highly symbolic ways to convey notions of kinship and power. Colours were not employed simply to decorate coats of arms. They actually supplied their bearers with *social* identities.

> THE SYMBOLIC CONNOTATIONS OF A PARTICULAR COLOUR WERE A VITAL MEANS OF DEFINING THE VALUES OF A FAMILY OR DYNASTY. JOUSTING KNIGHTS COULDN'T BE IDENTIFIED BY PERSONAL FEATURES. BUT THE COLOURS OF ARMORIAL SHIELDS AND TRAPPINGS WOULD INSTANTLY ASSOCIATE THEM WITH A PARTICULAR GROUP.

> I THINK YOU'RE *YELLOW!*

All sorts of artists and theorists have come up with symbolic grids for the mapping of colour. **Goethe** associated 'action' and 'light' with *yellow* and 'shadow' and 'negation' with *blue*. The Expressionist artist **Franz Marc** (co-founder with **Kandinsky** of the circle of the *Blaue Reiter* = 'Blue Rider', 1911) associated *blue* with the 'male' and 'spiritual' principles, *yellow* with the 'female' and 'sensual' principles, and *red* with 'materiality', 'heaviness' and 'brutality'.

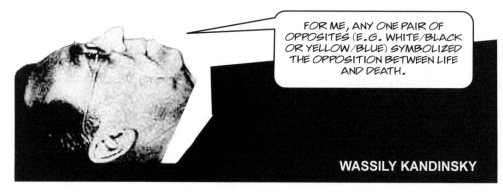

> FOR ME, ANY ONE PAIR OF OPPOSITES (E.G. WHITE/BLACK OR YELLOW/BLUE) SYMBOLIZED THE OPPOSITION BETWEEN LIFE AND DEATH.

WASSILY KANDINSKY

Colour and Light

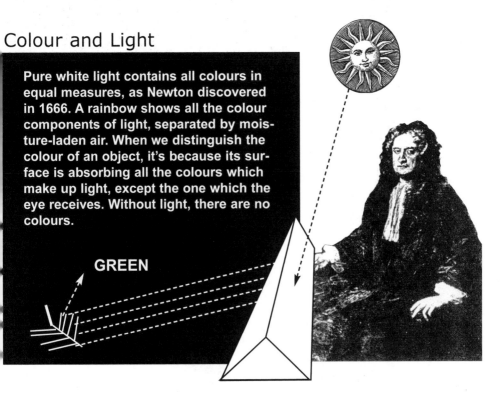

Pure white light contains all colours in equal measures, as Newton discovered in 1666. A rainbow shows all the colour components of light, separated by moisture-laden air. When we distinguish the colour of an object, it's because its surface is absorbing all the colours which make up light, except the one which the eye receives. Without light, there are no colours.

GREEN

Colour is inseparable from light. When we look at a picture in terms of light effects, we must first establish whether or not it has its own internal light. It's also interesting to observe where the light comes from. Sometimes a scene is illuminated by a source outside the image. Sometimes the source can be identified as an object within the picture itself - e.g. the sun, a candle, a lamp, etc. **Chiaroscuro** is the technique used to create the interplay of light and shadows.

TENEBRISM IS THE TERM USED TO DESCRIBE IMAGES IN WHICH THE DARK PORTIONS ARE MORE EXTENSIVE THAN THE ILLUMINATED ONES.

Light can also be used conceptually or symbolically. An obvious example is the kind of religious painting which uses a holy figure as the source of light. Throughout the Middle Ages, red was often the colour of 'divine light' and could be used to symbolize the Creation in contrast with the void, symbolized by blue. In early Christian and Byzantine churches, spiritual luminosity was produced by **mosaics** made of small glass cubes ('**tesserae**'). Bright colours and gold were fused into the tesserae, and the overall effect would depend on their arrangement at various angles, to sparkle, shimmer and reflect light as the viewer moved. The figure of a saint could be made awesome by a halo where the tesserae were set at such an angle that they would reflect light downward and inundate the figure's face with golden tones. Sometimes the source of divine light was the Gospel, in the shape of a golden and jewelled book held by Christ.

Light is a physical and earthly phenomenon. It's inseparable from material conditions relating to weather, atmosphere and time of day or night. The rainbow is clearly one of the most fascinating manifestations of physical light.

Until the end of the Middle Ages, the rainbow was believed to be a reflection of the sun on a dark cloud. Newton demonstrated that in fact it's produced by the refraction of light through drops of water.

Christian painters used the image of the rainbow in many different ways, sometimes emphasizing one or two colours to match symbolically the painting's central message. In the 17th century, artists such as **Jacob Van Ruisdael** used the rainbow as a symbol of transience by combining it with images of tombstones and ruins. In the 18th and 19th centuries, a number of artists depicted the rainbow to explore the 'key' to colour harmony through natural phenomena - e.g. **Angelika Kauffmann**, **John Constable**, **Caspar David Friedrich** and **J.M.W. Turner**. Both Wassily Kandinsky and Franz Marc used the rainbow motif in their early-20th-century pictures. In 1980, **Andy Goldsworthy** produced a striking instance of 'rainbow art' by causing and photographing a series of *Rainbow Splashes* in remote parts of the English countryside.

Although light is a material phenomenon, it has often been idealized as synonymous with truth and revelation. A colour produced by the passage of light through glass or by reflection on a highly polished surface can dazzle the eye. Some experience this merely as a physical disturbance, others as an almost mystical occurrence. **Marsilio Ficino**, writing in the 15th century, associated dazzling light with a form of spiritual illumination, for example. Light is en*light*ening - literally, in the sense that it illuminates colour and brings it to life, and symbolically, as a source of understanding.

BUT LIGHT IS ALSO DE*LIGHT*FUL: A SOURCE OF SENSUOUS PLEASURE AKIN TO LAUGHTER. IN SOME LANGUAGES, 'RADIANT' OR 'RADIANCE' AND 'LAUGHTER' SHARE COMMON ROOTS (THE FRENCH WORDS FOR 'LAUGHING' AND 'TO LAUGH' ARE 'RIANT' AND 'RIRE'; IN ITALIAN, THEY ARE 'RIDENTE' AND 'RIDERE').

It's important not to neglect the sensuous qualities of colour and light. They don't appeal only to sight (the least physical of the five senses) but to all the senses. Colours can come across as tactile, and light waves are comparable to sound waves, for example. Indeed, colours have often been associated with music. The Greeks had chromatic 'scales'; medieval and Renaissance practitioners talked of colour 'harmonies'; and much 20th-century art has sought to capture the 'rhythm', 'sonority' and 'resonance' of colours.

I WAS KEEN TO EMPHASIZE THE MATERIAL POWER OF COLOUR. I THOUGHT THAT HUES ARE CAPABLE OF EMANATING A SENSE OF MATERIALITY SO STRONG THAT THEY CAN COME ACROSS AS SOLID SUBSTANCES RATHER THAN EPHEMERAL EFFECTS OF LIGHT.

HENRI MATISSE

Colours can be used to decorate objects in a superficial way, or to express deep feelings and ideas. But in all cases, they are corporeal phenomena: not because they have a shape, mass or texture of their own but because without colours we would be insensitive to many of an object's most crucial properties.

Genres

The term 'genre' is used to indicate the 'kind' of picture we're dealing with. A fundamental distinction is the one between religious and secular images. In western art, religious themes are drawn from both the Old and the New Testament, as well as the lives of saints, miracles, visions and martyrdoms. Secular painting works with an astonishing range of themes and ideas. The portrait, the nude, landscape painting and still life are some of its main genres. For centuries, both religious and secular art were subjected to academic hierarchies. But modernity has drastically challenged conventional notions of artistic 'importance'.

Allegory and Symbolism

The word 'allegory' comes from Greek and means, literally, 'speaking otherwise': i.e. conveying the meaning of something by means of something else. Allegory is the representation of a figure, an abstract idea or a situation through symbolic images. All sorts of people, animals, plants and inanimate objects can be invested with symbolic meanings. 'Eternity' can be evoked by the image of a snake biting its tail;

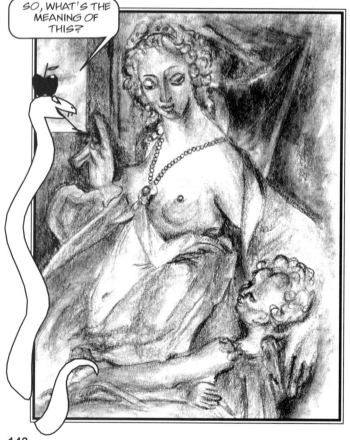

'Victory' by a winged woman; 'Peace' by a figure holding an olive branch; 'Prosperity' by a florid female bearing a sheaf of wheat; 'Poverty' by an old hag with shrivelled breasts; 'Sloth' by an upside-down hourglass; 'Luck' by a blindfolded woman; 'Love' by Venus; 'War' by Mars; 'Creativity' by the Muses; 'Christ' by the Tree of Life; 'Heaven' by a golden stairway; and so on. As these examples show, religious and mythological motifs are central to the expression of allegorical meanings.

An artist's use of symbols alerts us to the fact that another order of meaning often dwells beyond the shapes and colours of the image-surface. Sometimes the symbols are part of a rigorously contrived mesh of associations. A medieval painter, for example, would have automatically relied on the viewer's ability to recognize a Biblical character on the basis of the attributes that accompanied her/him: an object, an animal, an item of clothing. At other times, the symbols are personal inventions. They may feature recurrently in an artist's work with the same sorts of meanings attached to them. Or they appear sporadically or once only, in which case the viewer will have to make up her/his own mind as to what they mean, or as to whether they are meant to express anything at all beyond themselves.

IN MOST SYMBOLIC PICTURES, THERE ARE ELEMENTS WITH WHICH ANY PERSON TRAINED IN THE CULTURE WHERE THE PICTURE WAS MADE WOULD BE QUITE FAMILIAR, AND MORE ESOTERIC ELEMENTS RECOGNIZABLE ONLY BY AN ELITE OF INITIATES.

The exploration of allegory and symbolism helps us understand how pictures function by exploiting different orders of meaning simultaneously. Mythological, religious and, more recently, psychoanalytical sources may lie behind the shapes and colours of the picture-surface. Or else, the artist may have invented a symbolic system of her/his own... which means that the viewer is in a position to do exactly the same!

The Nude and the Portrait

The Nude has been an immensely popular genre in western culture. Developments in the representation of nudity from Classical times to the present suggest that the nude is a powerful cultural *icon*, which has played a vital role in the expression of sexual relations.

The study of the nude addresses the relationship between beauty and obscenity. Few people talk of a painted nude as they would of an unclothed body in real life, let alone a pornographic image. In other words, artistic nudity is not usually associated with obscenity. Yet some famous nudes (such as **Titian**'s and **Velazquez**'s) use some of the techniques which also characterize mass-produced images designed for erotic titillation. They display the female body as a passive object of the (male) gaze. Talking about artistic nudes as if they had nothing in common with more popular representations of unclothed bodies can be rather dangerous. The nude cannot be seen merely in formal terms.

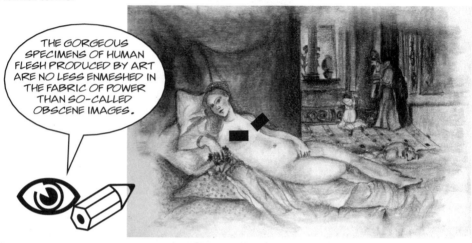

THE GORGEOUS SPECIMENS OF HUMAN FLESH PRODUCED BY ART ARE NO LESS ENMESHED IN THE FABRIC OF POWER THAN SO-CALLED OBSCENE IMAGES.

The earliest nudes available to us are Stone-Age statuettes. These are fetish figures of the female body characterized by exaggerated breasts, bellies and thighs. The representation of the nude is here fundamentally a symbol of fertility, not an exercise in anatomical accuracy.

In Classical Greece and Rome, the nude body was mythologized as a symbol of moral strength and virility. It was only the male nude that could carry positive messages. Representations of the female nude appeared late on the scene. And when they did, they were primarily Venus figures imported from the East, which associated them with ideas of *exotic* excess. With the advent of Christianity, explicit references to the naked body were suppressed because nudity was associated with sin. But erotic images were employed profusely in Romanesque and Gothic carvings, and in manuscript illumination. In the Renaissance, the revival of Classical ideas made it possible to reintroduce the nude as a legitimate subject for art. The Renaissance has given us some of the most enduring images of idealized nudity - e.g. **Botticelli**'s *Venus* and **Michelangelo**'s *David*. But many artists still associated nudity with unlawful carnal desires. It was the female body, in particular, that was linked to lasciviousness and immorality (e.g. **Cranach**). And several allegorical paintings emphasized symbolically the connection between seductiveness and the transience of pleasure (e.g. **Bronzino**).

144

The Renaissance also introduced the type of the reclining female nude (e.g. **Giorgione** and **Titian**). This paved the way for legion representations of a provocative female body laid out for the male viewer's delectation. The 'pin-up' Venus was one Renaissance stereotype. Another was the representation of woman as an object of violence (abduction, rape), in the context of mythological episodes. In the Rococo era, female nudes were overtly titillating playthings whose function was basically ornamental (e.g. **Boucher**). Neoclassicism tried to reinstate the male nude

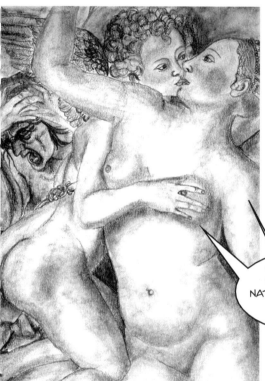

as the icon of both physical perfection and moral excellence (e.g. **David**). But with 19th-century artists such as **Ingres** and **Delacroix**, the nude was once again associated with female sexuality. **Manet**'s *Le Déjeuner sur l'herbe* (1863) - one of the most reproduced, parodied and caricatured paintings ever - was possibly the first picture to bring out sexual inequality by juxtaposing a naked woman and two clothed men. The image highlighted the stereotypical placing of woman on the side of 'nature' and of man on that of 'culture'.

YOU HAVE THE WILDNESS OF NATURE, THE SMELL OF OCEANS, THE...

JUST BE QUIET AND KISS ME!

In the 20th century, nudity has been rethought both thematically and structurally. Cubism reshaped the human body by 'cutting it up' and thus quizzing the link between Classical beauty (symmetry, proportion) and nudity (e.g. **Picasso**). Surrealism distorted the nude and allied it with grotesque creatures, showing that the body is the battleground of irrational fantasies (e.g. **Ernst**). In the 20th century, the nude hasn't (by and large) symbolized flawless beauty but the body at its most physical - as the site of pain (e.g. **Kahlo**); vulnerability (e.g. **Schiele**); sexual alienation (e.g. **Spencer**); childbirth (e.g. **Modersohn-Becker**).

Since the Renaissance, the female nude has been highly valued - but certainly not as a celebration of women's sexuality. Rather, it has been used as a means of *sublimating* and *policing* the sprawling, leaky and uncontrollable female body.

The nude female figure has been treated as raw material to be modelled by the male artist's 'genius'. The male artist's ability to transform the female body into an icon of purity has become the paradigm of western art. The more *naturalistic* the female body looks, the less natural it is. It has no hairs, pores, wrinkles, superfluous flesh, blemishes, moles or freckles. There are no traces of the body's natural exudations and secretions (blood, sweat, sebum, milk, tears, saliva, etc.).

THE FEMALE NUDE REPRESENTED BY MAINSTREAM WESTERN ARTISTS IS SEALED. BOUNDING FEMALE CORPOREALITY THROUGH ART IS A SYMBOLIC WAY OF PREVENTING IT FROM POLLUTING MAN'S WORLD AND OF FRAMING THE FEMALE BODY AS AN OBJECT ON DISPLAY.

Several theorists have attempted to define artistic nudity in relation to nakedness. Some (e.g. Kenneth Clark) value nudity as a refinement of the natural body accomplished through art, by contrast with nakedness as a natural state likely to cause embarrassment. Others (e.g. John Berger) take the opposite approach. They see nakedness as a natural expression of the body and therefore as something more authentically human than the artificial nude. Others still (e.g. Lynda Nead) argue that *neither* nakedness *nor* nudity are 'natural' because we only ever experience them as *cultural representations*.

IN THE *HELLENISTIC* ERA (*330-27 BC*), THEY INTRODUCED THE GENRE OF CARICATURE, A DISTORTION OR EXAGGERATION OF A PERSON'S ATTRIBUTES. THE PORTRAIT WAS POPULARIZED BY THE ROMANS, AS A GENRE MEANT TO DEPICT SPECIFIC INDIVIDUALS. IT THEN FELL OUT OF FASHION AND DIDN'T REAPPEAR TILL THE GOTHIC PERIOD. FROM THE RENAISSANCE ONWARDS, IT HAD A PRESTIGIOUS STATUS IN THE WORLD OF ACADEMIC ART.

The Egyptians portrayed their gods and rulers as stylized and idealized masks, and mortals in a more naturalistic fashion. The Etruscans used to place a stylized sculpture of a person's head on the lid of the urn containing her/his ashes. The Greeks were the first to take interest in physiognomical description (i.e. facial features supposed to reveal a person's inner character).

Portraiture shows us art at its most 'constructed', for it turns supposedly 'real' human beings into artefacts. On the one hand, the portrait is supposed to represent a real, specific and unique individual. On the other, it must convey a person's social and cultural status - that is, a role or *persona* rather than a person. The word *persona* comes from Latin and originally meant both 'person' and a 'theatrical role' or 'mask'. Being a person doesn't simply mean being a flesh-and-bone individual. It also means being a *character* on a cultural *stage*. A ceremonial portrait of a Renaissance monarch, or **Andy Warhol**'s 'Marilyn Monroe' pictures, represent cultural symbols far more than they depict actual people.

There is plenty of evidence that physical likeness has hardly ever been the portrait painter's primary concern. Likeness refers to 'exterior' resemblance, i.e. the extent to which a picture captures a person's physical attributes. But portrait painters throughout the ages have endeavoured to make likeness a function of *identity*, i.e. a person's 'essential' character. The sitter's features must convey personality traits (virtues, vices, tastes, etc.). But who really knows what the inner self 'looks like'? Knowing what people look like has very little to do with knowing who they are.

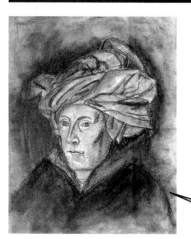

INSIDE ME, THERE'S A RAGING DEMON TRYING TO GET OUT!

The depiction of social masks takes precedence over the representation of individual bodies. In Elizabethan England, laws were created to control royal portraiture and to ensure that only accomplished artists had a right to portray the monarch. Queen Elizabeth I never had an official court artist solely responsible for promoting her image. The Queen sat often and for various painters throughout her reign. But in the last decade, artists were kept away to avoid any record of her physical deterioration. It was important to go on advertising the image of the Queen as a mask of beauty and youth in the interests of political stability. The portraits for which the Queen actually sat were only a small proportion of the legion images of her which both the aristocracy and common people were eager to exhibit in their houses. The large-scale production of royal portraits was made possible by the use of 'patterns'.

The **pattern** enabled different hands to create the same mask. How did the pattern process work? A cut-out of the head was covered with pinpricks placed along the lines of the person's features.

The cut-out was then applied to a support (panel or canvas), and the lines were traced onto the support by rubbing chalk through the holes. The artist then built up the portrait around the tracing of the head.

The execution of the rest of the painting was no less formulaic than the rendering of the head. Handbooks were consulted to produce appropriate types of clothing, lace and jewels. Where dress and accessories were supposed to carry allegorical meanings, the advice of poets had to be sought.

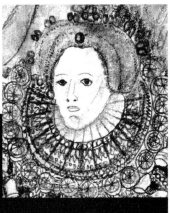

Legislation had to ensure that the patterns in circulation were officially approved and that only licensed artists had the right to copy them. All these rules and policies show that a portrait wasn't meant to give a likeness. It was a cog in the propaganda machine.

A portrait is not just a picture of the self in art. It is a picture of the self as art. The portrayed self is a *mask* and masks both block access to the inner self and help us make a social commitment. They protect us from the prying gaze of others. But they also give others certain images of ourselves which they can recognize and to which they can relate. Portraits speak volumes about a culture's dominant values.

FOR EXAMPLE, IN WESTERN CULTURE PORTRAITS ASSIGN A PRIVILEGED ROLE TO THE **HEAD**. THIS IS A WAY OF SUGGESTING THAT A PERSON'S WORTH COINCIDES WITH WHAT CAN BE SEEN IN THE FACE AND, THROUGH THE FACE, IN THE **MIND**. THE BODY AND THE SENSES ARE SUBORDINATED TO THE INTELLECT.

Landscape and Genre Painting

HISTORY PAINTING (religion, mythology, Classical history)

PORTRAITURE (monarchs and influential patrons)

LANDSCAPE PAINTING

GENRE PAINTING (populated by 'common' people)

ANIMAL PAINTING

GENRE PAINTING (representing inanimate objects)

Quite obviously, both landscape and genre painting are given a fairly lowly status.

Academic art had little respect for landscape painting because it saw it as tied down to a particular 'spot' and hence incapable of expressing universal ideas. Romantic art challenged this position. The expression of the Romantic 'sublime', the aesthetic feeling brought about by nature's most awe-inspiring manifestations, would be unthinkable without landscape painting. Both **J.M.W. Turner** (1775-1851) and **John Constable** (1776-1837) raised landscape painting to a new status in the hierarchy of the genres. These two artists were often misunderstood by their contemporaries. But there's no doubt that in different ways they altered radically people's perceptions of landscape. Turner experimented with light and colour to dissolve static forms into a world of constant movement and swirling forms. Constable rejected academic codes through his use of both colour (e.g. an unconventional range of greens) and line: elements of scenery are often captured by scoops, whorls and dabs of paint.

149

Images of landscapes don't merely reproduce nature. They create realities with specific languages of their own. And they communicate particular ideologies. Sometimes the representation of *land*, for example, is not an image of nature but of 'property'. In many pictures by Thomas Gainsborough (1727-88), for example, picturesque or idyllic scenery and rolling farmland are used to symbolize the wealth and power of the figures portrayed in these rural settings.

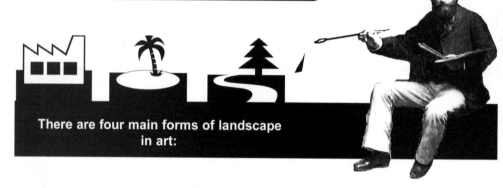

THERE ISN'T ONE SINGLE DEFINITION OF LANDSCAPE. IT CAN DENOTE NATURAL SCENERY UNTOUCHED BY HUMANS; LAND TRANSFORMED BY HUMAN USE INTO FIELDS, FARMS, ROADS AND CITIES; THE PICTURE OF A LOCAL COMMUNITY WITH ITS CUSTOMS AND TRADITIONS; A VISUAL COMMODITY FOR TRAVELLERS AND TOURISTS; AN IDEALIZED IMAGE OF NATIONAL TERRITORY.

There are four main forms of landscape in art:

Historical landscape depicts past worlds: rural vistas dotted with Classical ruins or villas; medieval castles and abbeys; prehistoric stone circles; caverns and grottoes.

Agricultural landscape is centred on farming. At times, it represents real peasant life. But often it uses the image of a neatly-laid-out countryside as a metaphor for prosperity and good management. It also includes hunting scenes (a symbol of male prowess) and artfully 'landscaped' gardens (a symbol of female domestic virtues).

Urban landscapes are depictions of cities. Already popular in the 16th century as a means of documenting a city's cultural and economic status, urban landscapes were given prominence by social developments of the 19th century, when the city became a symbol of vitality and dynamism.

Industrial landscapes finally, shows industrialized spaces where all traces of agricultural activity have vanished. Some industrial landscapes comment pessimistically on the destruction of nature by the machine. Others use billowing smoke plumes and the steam of locomotives to express energy and movement.

The term **genre painting** is used to describe realistic scenes from everyday life. Since it places great emphasis on material objects, this type of art is especially suited to cultures which value ideas of property and possession.

INDEED, GENRE PAINTING GAINED PROMINENCE FOR THE FIRST TIME IN 17TH-CENTURY HOLLAND, WHERE IT EMBODIED THE SECULAR ASPIRATIONS OF THE RISING MERCANTILE CLASSES.

A widespread type of genre painting is **still life**, a picture of fruit, flowers, household objects, and game. Still life became particularly popular in the 16th and 17th centuries. It is important, when studying still-life paintings, to remember that they play a twofold role: they are decorative, but they also portray a society's tastes and values - especially, its sense of what a desirable possession is, both as a subject for painting and as a picture in its own right.

The reason why academic art regarded genre painting as inferior to all other kinds of painting was its association with the 'ordinary'. When we say that a picture represents common things or experiences, the word 'common' can mean either of two things: that those things and experiences are *shared* by many people, or that they are *trivial* and *insignificant*. The latter meaning dominated academic criticism. When genre painting involved the representation of people, these were normally peasants and manual labourers - i.e. people conventionally associated with ignorance and lack of taste.

Political and economic developments of the late 19th century and early 20th century redefined the concept of the 'everyday'. Everyday experiences were no longer associated with common people and their menial tasks. The everyday was now the glittering world of urban society. In the same period, some artists engaged in genre painting to defy conventional notions of what's 'important' and what isn't. **Paul Cézanne** (1839-1906), for example, used still life to experiment with structure and colour. He showed that what makes a picture 'important' is not lofty subject matter but its formal properties. Following this lesson, **Cubism** employed still life to do something a lot more radical than simply represent everyday objects. Dada and **Surrealism** used everyday objects to unsettle people's perception of their familiar surroundings. And **Pop Art** exploited the imagery of consumer society to quiz the very meaning of art.

Conclusion: Consuming Art

The **museum** is an ideological apparatus. Its collections organize disparate cultural artefacts into coherent pictures of 'art'. Art is the invention of museological practice. It is a construct designed to universalize people's experiences, as if historical and geographical differences were irrelevant. The museum is a *colonizing* institution because it tries to absorb diverse traditions into one totalizing idea of 'Tradition'. This is bound to leave out many artworks and artists.

The museum's ideology puts off many potential visitors. Things are complicated by the belief that it is only *valuable* objects that deserve to be exhibited. Many of us associate 'value' with special, often ancient, artefacts which have nothing in common with everyday objects.

But the concept of value is a movable feast. Aesthetics has sometimes linked it to *universal* ideas of beauty, and sometimes put it down to purely *personal* matters of taste. Economically, too, value can mean opposite things. It can be connected to *accumulation* ('the more I *own*, the more valuable I am'), or to *expenditure* ('the more I *buy*, the more valuable I am'). We should not forget that the 'value' of artworks is never purely aesthetic. It is economic, as well. Artworks are related to commodities in two ways: they are objects that can be bought and sold; and they often draw inspiration (as we have seen) from the imagery of everyday commodities.

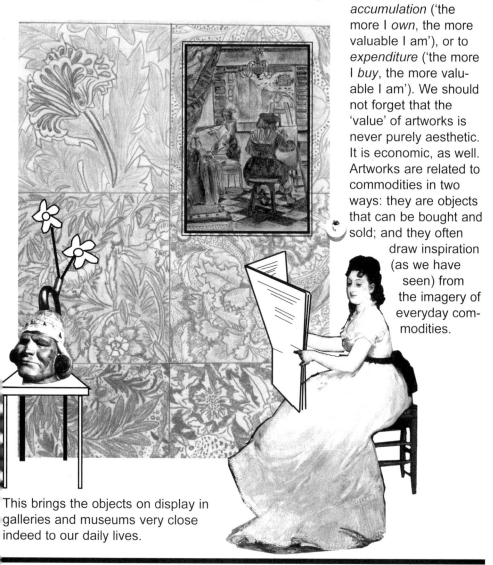

This brings the objects on display in galleries and museums very close indeed to our daily lives.

Going to a museum shouldn't feel like visiting a cemetery. The works that inhabit that space are not dead. They are trying to speak to us, and in many languages. But their voices can only be heard if we engage in a dialogue with them - in other words, if we pay attention to their form as individual objects; allow them to have an impact on our minds and bodies; appreciate them in relation to the context in which they're exhibited; and, last but not least, bear in mind that these objects can exist in countless other forms when they're reproduced and transformed into commodities.

Art can be consuming. It can use up our thoughts and emotions, both when we're trying to 'make' it and when we're trying to 'understand' it. And it can also soak up our wealth (assuming we're wealthy) when we decide to invest in it financially. But it's also the case that we consume art.

Not many people are affluent enough to actually buy works of art. But all of us 'consume' art when we look at its objects (make judgements about them or draw pleasure from their signs). And often, our consumption of art relies on mass-produced commodities such as postcards, diaries, t-shirts, calendars and mugs. These reproductions are often given a lowly status by comparison with the 'worthy' original. But things are not so straightforward. Commodified reproductions of artworks make them available to a wider range of people than just connoisseurs. They take away the inhibiting sense of uniqueness associated with gallery displays. But sometimes the commercial dissemination of a 'masterpiece' serves to strengthen its value. If it's so great that it deserves to be transformed into other objects, then seeing the original must be a *special* experience indeed!

Glossary

Movements, Styles and Techniques

Please note that the most popular techniques are discussed in the section 'Materials and Techniques'.

A

ABSTRACT EXPRESSIONISM Movement in American painting developed in the 1940s. There are two main styles in the movement: 'colour-field' painting, adopted by **Mark Rothko**, **Barnett Newman** and **Clyfford Still**, consisting of the application of unified blocks of colour to large canvases; and 'gestural' painting, adopted by **Jackson Pollock**, **Willem de Kooning** and **Hans Hofmann**, based on techniques such as dripping or throwing paint directly onto the canvas.

ABSTRACTION Styles which do not represent recognizable objects from the world around us and use simplified and schematized forms. Colour and line are very important to abstract artists.

ACADEMIC ART Styles and themes used within an academy system (particularly history painting). Academic art is associated with the 'Grand manner', i.e. representations which highlight universal - rather than particular - concepts.

ACRYLIC Synthetic paint which unites some of the properties of oil and some of those of watercolour, widely in use since the 1940s.

AESTHETIC MOVEMENT Movement of the 1880s and 1890s devoted to the ideal of 'art for art's sake': i.e. art is autonomous and should only be judged by aesthetic standards.

ALLA PRIMA (Italian: 'at first'.) Technique consisting of the application of colour directly to the canvas without underpainting.

ANAMORPHOSIS Technique through which an image is distorted in a painting. The image will appear in its undistorted form when looked at from a certain angle or reflected in a curved mirror. It was widely used in the 16th century, e.g. by **Leonardo da Vinci** and **Hans Holbein**.

APPLIED ART Term used to describe art forms which serve a practical purpose (e.g. furniture, wallpaper, glassware, etc.).

ART DECO European and American movement of the 1920s and 1930s. It sought to oppose mass production by returning to the values of pre-industrial craftsmanship. It often used precious materials such as ivory and ebony, and elegant forms.

ART INFORMEL (French: 'art without form'.) Works produced in the 1950s by artists such as **Alberto Burri, Jean Dubuffet, Jean Fautrier, Hans Hartung** and **Jean-Paul Riopelle**. They wished to create a new language, based neither on figurative nor on geometrical forms. Their main techniques were improvisation, free brush stroke, thick layering of paint, and the use of new materials such as charred wood, iron plates and plastic.

ART NOUVEAU International style of decoration and architecture which flourished in the 1880s, 1890s and early 1900s. Its name derives from the Parisian interior decoration gallery Maison de l'Art Nouveau (1896). In Germany, the same style was termed *Jugendstil* (from the magazine *Die Jugend* = 'Youth'), and in Italy *Liberty* (after the London store). Its main decorative motifs are writhing plant forms. One of the main graphic artists in this style was **Aubrey Beardsley**. In architecture, the leading figures were **C.R. Mackintosh** in Britain, and **Antoni Gaudi** in Spain.

ARTE POVERA (Italian: 'poor art'.) Term created in 1967 to describe a group of Italian artists (e.g. **Mario Ceroli, Mario Merz, Michelangelo Pistoletto**) whose approach to art was anti-formal and anti-commercial. They valued the artist's engagement with the physical qualities of her/his medium, and worked with a wide range of neglected materials: cement, earth, felt, rope, newspaper, etc.

ARTS AND CRAFTS MOVEMENT This movement developed in the second half of the 19th century as a reaction against industrialization and mass production. It valued pre-industrial craftsmanship and looked back nostalgically at the Middle Ages. But it was also inspired by Socialist ideas, especially the notions that non-alienated labour is the supreme expression of human creativity and that art is a form of education. The inaugural figure in the movement is **William Morris**. He exemplified these ideas through his own designs (for wallpaper, stained glass and textiles), and through the work of the firm Morris, Marshall, Faulkner and Co., founded in 1861.

ASSEMBLAGE Use of images and objects from everyday life to experiment with a wide range of materials and techniques. Ordinary things become formal arrangements of lines, colours and three-dimensional shapes. The Dada artist **Marcel Duchamp** was one of the first to turn mass-produced objects into artworks. He called these objects 'readymades'.

B

BARBIZON SCHOOL Group of French artists (including **Camille Corot, Gustave Courbet, Jean-François Millet**) of the early to mid-19th century, who gathered in the village of Barbizon to paint from nature in the open air, concentrating particularly on the effects of light.

BAROQUE (Italian *barocco*: 'bizarre' and Portuguese *barroco*: 'misshapen pearl'.) Style which flourished in Rome in the early 1600s, to survive in various forms

until the 18th century. Most artworks in this style were highly ornamental, theatrical and exuberant. Buildings were heavily decorated with relief and stucco work. Painting was illusionistic and emphasized the sense of movement through swirling lines, billowing draperies, fleecy and racing clouds. This style was meant to have a strong emotional impact on the viewer. **Gianlorenzo Bernini**, **Michelangelo Merisi da Caravaggio**, **Guido Reni**, **Rembrandt van Rijn**, **Peter Paul Rubens** and **Diego Velazquez** are amongst the main Baroque artists. Sometimes 'baroque' is used as a term of abuse to describe anything considered 'over the top'.

BAUHAUS School founded by the architect **Walter Gropius** at Weimar in 1919. Bauhaus artists wished to bring together the visual arts, sculpture, architecture, and decorative arts such as weaving and pottery, by concentrating on principles of design. They saw artists as craftsmen, but were also keen to produce designs suited to machine production. They favoured simple, geometrical and highly refined forms.

BODY ART Art form developed in the late 1960s and 1970s in which artists make use of the body. Body art often takes the form of public performances meant to shock or bore the viewer, to express the violence and monotony of everyday life. Instances of body art include self-mutilation, obscene exhibitionism, lengthy lectures. The artist **Yves Klein** painted the naked bodies of female models and dragged them around on a canvas situated on the floor. **Orlan** used mutilation to make feminist statements about the abuse of the female body.

C

CAMDEN TOWN GROUP English group of painters founded in 1911 and clustered around **Walter Sickert**'s studio in Camden Town (North London). Much of their subject matter came from urban working-class life. They favoured strong forms and colours.

CAPRICCIO (Italian: 'caprice'.) Painting based on fantasy. In landscape painting, it refers to the mixing of real and fictional elements. **Canaletto** used this approach in the 18th century. In more general terms, 'capriccios' are works based on fanciful, bizarre and often disturbing subject matter, as shown by **Francisco de Goya**'s *Los Caprichos* made in the 1790s.

CARICATURE Image representing a person in distorted and exaggerated ways, usually for satirical and political purposes. Caricature has been widely used by a variety of artists since the Renaissance.

CARTOON (Italian *carta*: 'paper'.) 1) Full-scale drawing on paper for a painting, to be subsequently transferred to a canvas or panel. 2) Humorous drawing, vignette, or caricature.

CHIAROSCURO (Italian: 'light-dark'.) Technique through which shapes are modelled through the gradation of colour, from the lightest to the darkest values. Particularly dramatic effects can be achieved through strong contrasts of light and darkness, as shown by the paintings of **Caravaggio** and **Rembrandt**.

COBRA (from the initials of the cities were the artists lived: Copenhagen, Brussels, and Amsterdam). International association of artists (1948-51) who wished to encourage the idea of painting as a free expression of the unconscious. They promoted the spontaneous handling of wild colours, dynamic lines, and images derived from fantasy, folklore, mythology and children's paintings. **Karel Appel** is an example of Cobra art.

COLLAGE (French *coller* 'to stick'.) Cutting and pasting onto paper of pieces of newspaper, cardboard, wallpaper and cloth. This technique was popular amongst Cubist and Surrealist artists.

COMBINE ART Painting that incorporates three-dimensional objects into a picture. Works by the American artist **Robert Rauschenberg**, produced in the 1950s, are an example of this technique.

COMMERCIAL ART Art related to advertising and industry.

CONCEPTUALISM International phenomenon of the 1960s. The most important part of the artwork is not the artist's technical skill but a concept embodied by the work. The work is important in itself, not as an illustration of something else. Conceptualism wants images to be language-like: artworks that could be read. It uses many forms and media: written texts, photographs, diagrams, maps, films. These are displayed either in galleries or in particular sites where the environment is supposed to contribute to the significance of the work. Among the practitioners of conceptual art are **Sol LeWitt**, **Douglas Huebler** and **Bruce Naumann**.

CONCRETE ART Term introduced in the 1930s to describe a kind of abstract art concerned with a work's pure plastic elements. Works are supposed to develop according to their own autonomous laws, not according to natural laws. One of its main exponents is **Max Bill**.

CONSTRUCTIVISM Abstract movement which originated in Russia in 1913. **Naum Gabo**, **Ljubov Popova**, **Antoine Pevsner**, **El Lissitzky**, **Alexander Rodchenko** and **Vladimir Tatlin** were practitioners of constructivist art. They believed in the importance of raw materials, especially glass, wood and wire, and thought that art should reflect developments in modern technology. Sculptures were 'constructed' out of industrial materials and techniques. Paintings often used abstract shapes reminiscent of industrial technology.

CUBISM Style invented by **Pablo Picasso** and **Georges Braque** around 1907-8. Various aspects of the same object are shown simultaneously from different angles. The laws of perspective are rejected: instead of creating the illusion of three-dimen-

sionality, cubism depicts things in terms of the two-dimensional space of the canvas. 'Analytical' or 'hermetic' cubism (1908-12) is based on the analysis of objects into their component parts and uses muted colours which often make the objects hard to recognize. 'Synthetic' cubism, initiated by Braque around 1912, introduces bits of paper into the painting. From then on, both Picasso and Braque experimented with collage and mixed-media techniques. By 1912, cubism had become an international style. Its practitioners include **Fernand Léger**, **Albert Gleizes** and **Jean Metzinger**.

D

DADA International movement which flourished between 1915 and 1922. Its main centre was the Cabaret Voltaire in Zurich, where the poet **Tristan Tzara** and others gathered and put on riotous performances. Dada attracted not only visual artists but also writers and musicians. It was opposed to the elitism of the traditional art establishment and promoted an 'anti-art' designed to outrage the bourgeoisie. It wanted art to express the irrational side of life and to play with absurd ideas in both humorous and shocking ways. Artists in this movement used a variety of media and techniques such as collage, wood relief and photomontage. Dada artists include **Marcel Duchamp**, **Man Ray**, **Jean Arp**, **Raoul Hausmann** and **Francis Picabia**.

DECADENCE Term used to describe moral and artistic decline. More specifically, it denotes a visual and literary movement which developed in the late 19th century in England and France. It was anti-bourgeois, believed in the artist's isolated role, and favoured themes associated with sexual obsession, death and perversion. **Aubrey Beardsley** and symbolist painters such as **Odilon Redon** in the visual domain, and **Charles Baudelaire**, **Huysmans** and **Oscar Wilde** in the literary one, are among its main figures. Decadence is also associated with the idea of *fin de siècle* (French for 'end of the century'), a term often used to describe the anxieties of a culture coming to the end of a phase and facing a new one.

DECORATIVE ART Art devoted to the design and decoration of objects which may have practical - rather than purely aesthetic - functions (e.g. clothing, furniture, textiles, etc.).

DECOUPAGE Technique based on cutting out shapes, pasting them onto a surface and then lacquering them.

DE STIJL Movement founded by **Theo van Doesburg** and **Piet Mondrian** in Holland in 1917. Their works used simple geometrical forms and elements, i.e. straight lines and primary colours, and endeavoured to express harmony and clarity. These artists believed that art should become an objective discipline, capable of reflecting the order of the universe.

DIVISIONISM Technique based on the application of pure colours in spots or dashes. The artist doesn't mix the pigments him/herself on the palette before applying

them to the canvas. The mixing happens in the viewer's eyes: it is an optical effect. **Paul Signac** and **Georges Seurat** are often associated with this style. When artists use precise dots, their style is termed 'pointillism'.

E

EARTH AND LAND ART Art produced mainly in the late 1960s and 1970s by 'working with' the natural environment in various ways: going for walks and documenting them through maps, photographs and materials such as slate, mud and sticks (e.g. **Richard Long**); manipulating the actual environment (for example by shifting huge amounts of earth and rocks) to produce massive 'sculptures' out of the landscape (e.g. **Robert Smithson**).

ENVIRONMENTAL ART Term introduced in the early 1960s to describe a type of art in which works interact with their surroundings. Environmental artists often place wood, metal or glass structures in an open space, in such a way that they gain meaning from their environment and that the environment, in turn, reveals itself through them. The work's environment is not simply a context for the work but part of the artistic process. The viewer can walk into or through these assemblages and gather various impressions about both the works and their surroundings. **Alice Aycock**, **Nancy Holt**, **Ed Kienholz**, **James Dine**, **Claes Oldenburg** and **Mary Miss** are the major environmental artists.

EXPRESSIONISM Movement which developed, primarily in Germany, between 1905 and 1930. Its artists were less concerned with imitating the outside world than with expressing their most intimate and powerful feelings. Violent colour, dramatic brushwork, distortion and exaggeration were the main vehicles used by these artists to depict their personal emotions. Many of their works represented the alienation and violence of modern urban life, the horrors of war, and personal and political corruption. **Vincent van Gogh** (particularly in his later works) was a major source of inspiration for Expressionism. Its leading practitioners were **Max Beckman**, **Erich Heckel**, **Alexei von Jawlensky**, **Ernst Ludwig Kirchner**, **Oskar Kokoschka**, **Franz Marc**, **Edvard Munch**, **Emil Nolde**, **Max Hermann Pechstein**, **Georges Rouault**, and **Egon Schiele**.

F

FAUVISM *Fauves* ('wild beasts') was the term coined by the critic Louis Vauxcelles to describe paintings by **Henri Matisse**, **André Derain**, **Maurice de Vlaminck** and others, exhibited in Paris in 1905. These artists used pure, strongly contrasting colours and energetic brushwork, to represent powerful feelings and intense emotions. Fauvism is often associated with Expressionism but is less harsh and conveys a more cheerful and enthusiastic world view.

FIGURATIVE ART Term used to describe styles which offer representations of recognizable objects. The term 'representational' is sometimes used in the same sense.

FOLK ART Artefacts such as woodwork, pottery and fabrics produced within a particular region or community, decorated with traditional patterns and colours. Folk art usually has an autonomous life: it is not deeply affected by movements in the so-called 'fine arts'.

FORESHORTENING Technique through which perspective is applied to a single figure or object to create the illusion of depth.

FROTTAGE (French: 'rubbing'.) Drawing technique based on placing paper on a rough surface (e.g. grained wood or sackcloth), and rubbing it with pencils or crayons, to transfer onto it the effects of the underlying surface. **Max Ernst** (1891-1976) is one of the main practitioners of this technique.

FUNCTIONALISM Styles in which the form of an object is inseparable from its function. An object is beautiful if it serves the purpose for which it was designed and made. This idea was enthusiastically promoted at the beginning of the 20th century by the American modernist architect **Louis Sullivan**, who stated that 'form follows function'.

FUTURISM *Avant-garde* movement founded in Italy in 1909. Its artists, especially **Giacomo Balla**, **Gino Severini**, **Carlo Carrà** and **Umberto Boccioni**, were fascinated by modern technology. They sought to convey a sense of dynamism through energetic lines, and to capture the sensation of speed by representing several images of the same figure in various positions on one single canvas.

G

GOTHIC Term used to describe a style which flourished in Europe from about 1150 to 1500. Paintings in this style did not generally attempt to create the illusion of three-dimensional space. The depiction of fluid lines was preferred to the representation of solid space. Human figures were characteristically elongated to give an impression of elegance, spirituality and refinement. Intricate patterns and minutely-detailed representations of natural themes often featured in Gothic art. Manuscript illumination was one of the most highly-developed arts of the period. Gothic artists include **Simone Martini**, **Cimabue**, **Gentile da Fabriano**, **Lorenzetti**, **Lorenzo Monaco** and **Duccio**.

GRAFFITI ART Large-scale and colourful tableaux painted on walls, and sometimes on mobile sites (buses, railway carriages), which became popular in the US and then in Europe in the 1980s. It often carries a political message - because of its themes, and because it subverts conventional ideas of space by displaying art on exterior surfaces rather than inside galleries.

GRATTAGE Extension of the principles of 'frottage' from drawing to oil painting. This technique was invented by **Max Ernst**.

GROTESQUE Fanciful decoration using fabulous monsters and hybrid figures which combine human, animal and vegetable elements. The term derives from the Italian *grotta* ('cave') because these decorative elements were first found in underground Roman ruins. 'Grotesque' is now used to designate all sorts of distortions and exaggerations, especially of the human body.

H

HAPPENING This term was coined in 1959 by **Allan Kaprow** to describe a spontaneous theatrical event, which may use the visual arts, music or acting. In simple words, a happening is a way of making art by making something happen. Once it has happened, the artwork is over. **Joseph Beuys**, for example, made an artwork by talking to a dead hare (his head covered with honey and gold leaf), with the audience observing him through a window (1965). On another occasion, he spent five days in an enclosure inside an art gallery in the company of a coyote.

I

ICONOLOGY (Greek *icon:* 'image'.) Study of the meaning of artworks in relation to their cultural, social and historical contexts.

ILLUMINATION (latin *illuminare*: 'to adorn'.) Colourful decoration of manuscripts through miniatures, luxurious borders and capital letters, widespread in the Middle Ages and in the Renaissance.

IMPRESSIONISM Movement that originated in France in the 1860s. Its name derives from a painting by **Claude Monet** entitled *Impression: Sunrise* (1872), in which the artist depicted his perception of light essentially through colour. All Impressionist artists were fascinated by the relationship between colour and light. They wished to capture the visual impression made by a scene and were not concerned with giving a factual report of it. Impressionism is associated with a spontaneous style of painting, where the brushwork is often visible, and a luminous palette, which tends to use pure pigments. Impressionism caused much outrage in asserting that the artist paints what s/he perceives rather than a solid world. It was also unconventional in its choice of themes, usually drawn from nature or from urban scenes, rather than history, mythology or religion. Some of the main Impressionist painters were **Edouard Manet, Claude Monet, Edgar Degas, Berthe Morisot, Auguste Renoir, Gustave Caillebotte, Camille Pissarro** and **Alfred Sisley**.

INSTALLATION Three-dimensional work which uses a wide range of materials and media and often includes human beings and other living creatures.

J

JUNK ART Art form developed in the 1950s and 1960s, which used as its raw materials industrial debris, such as scrap metal and machine parts. The sculptor **Cesar**, for example, employed car bodies crushed by a hydraulic press as his building blocks.

K

KINETIC ART Art form, which became particularly popular in the 1960s, incorporating real movement (e.g. **Jean Tinguely**'s motor-activated sculptures) or simulated movement (e.g. the use of light effects to create the illusion of activity).

L

LUMINISM Style of 19th-century landscape painting developed in the US, characterized by extreme luminosity. Most paintings in this style are small and deliberately reduce the size of objects to place emphasis on the effects of light bathing the scene. Luminist painters include **Fitz Hugh Lane**, **Martin Johnson Heade** and **John Frederick Kensett**.

M

MACCHIAIOLI (Italian *macchia*: 'stain' or 'blot'.) Group of Italian painters based in Florence, active between 1855 and 1865. They rejected the dominant academic style and painted by using spots of colour and short brush strokes. The leading figures were **Telemaco Signorini** and **Giovanni Fattori**.

MANNERISM Style which prevailed in Italy between 1530 and 1600. The term *maniera* meant 'grace' or 'style', and was associated with the elegance of **Michelangelo**'s and **Raphael**'s paintings. But as time went by, artists developed styles which actually went against the order and balance of those paintings. They experimented with elaborate compositions, complex postures, and exaggerated expressions, to convey a dramatic sense of movement. Mannerism came to be

associated with excessive virtuosity and whimsy. Mannerist painters include **Agnolo Bronzino, Rosso Fiorentino, Giulio Romano, El Greco, Giambologna, Jacopo Pontormo, Jacopo Tintoretto** and **Parmigianino.**

METAPHYSICAL PAINTING Movement founded in Italy in 1917. Its most typical features were a dream-like atmosphere, produced by unnatural lighting and illogical perspective, and eerie images, such as dummies, fragments of statues and skeletons. Its main representatives were **Giorgio De Chirico, Carlo Carrà** and **Paul Delvaux.**

MINIMALISM A movement which became prominent in the 1960s, largely as a reaction against the gestural techniques of Abstract Expressionism. It used elementary geometric shapes, often in the form of industrially produced objects - e.g. bricks, steel cubes, perspex and fluorescent tubes. Minimalist works are wholly abstract and impersonal. **Carl Andre, Donald Judd** and **Frank Stella** are examples of minimalist artists.

MIXED MEDIA Artwork produced by the use of different media - e.g. paints, photographs, found objects, videos, sculptures, etc.

MONTAGE Composite image made from the superimposition or blending of various pictures.

MOSAIC Picture made by placing fragments of glass, marble or semi-precious stones ('tesserae') onto a bed of plaster or cement.

MUSÉE IMAGINAIRE (French: 'imaginary museum.) Term invented by **André Malraux** to describe the dissemination of artworks through reproduction - e.g. in illustrations, postcards, advertising, etc.

N

NABIS Group of French painters of the 1880s who developed a method of painting in pure, flat colour. They believed that a picture is an area covered with colours, before being a representation of anything in the world. Nabis artists included **Pierre Bonnard, Edouard Vuillard** and **Maurice Denis.**

NAIVE PAINTING Art characterized by a deliberately unsophisticated approach. It employs bright and non-naturalistic colours and doesn't use the rules of perspective. The works of **Henri Rousseau** (1844-1910) are examples of naive art.

NATURALISM Artistic approach based on minute observation and detailed imitation of aspects of the natural world.

NEO-CLASSICISM Movement of the second half of the 18th century which aimed at reviving the values of ancient Greek and Roman art, especially its elegant and symmetrical lines. Neo-Classical artists often borrowed themes and motifs from Classical art.

NEO-EXPRESSIONISM Revival of Expressionist techniques and styles in the 1970s, in the US and Europe (especially Germany). Like Expressionism, Neo-Expressionism was primarily interested in conveying personal feelings and emotions with great alacrity.

NEO-PLASTICISM Term coined by **Piet Mondrian** to describe a rigidly geometrical form of abstraction, based on vertical and horizontal lines and on a limited range of colours: the primaries, white, black and grey.

NEO-ROMANTICISM Form of 20th-century painting which unites features of Romanticism and Surrealism. **John Piper** and **Paul Nash**, for example, combined a keen interest in nature and fantastic or dream-like elements in their visionary landscapes.

O

OBJET TROUVÉ (French: 'found object'.) A mass-produced or natural object turned into a work of art by simply being selected by an artist and exhibited in public. **Marcel Duchamp** made such a work in 1917 by picking a porcelain urinal and signing it 'R. Mutt'. **Paul Nash** (1889-1946) used natural objects such as pebbles and broken tree branches. Creation is not important. What matters is the selection of an object and its relocation.

OP ART ('Optical Art'.) Movement of the 1960s based on optical illusion. Although images are static, they can simulate the idea of movement when colour and line are used in such a way that they appear to pulsate, flow or vibrate. In the works of **Bridget Riley** and **Pal-Ket Vasarely**, shapes and colours appear to float and shift.

ORPHISM An offshoot of Cubism which developed in Paris between 1911 and 1914. Orphic painters wanted art to be disengaged from the representation of natural shapes. They developed a non-figurative language in which the expressive qualities of colour played a crucial role. **Robert Delaunay** experimented with colour rhythms produced by the simultaneous contrast of colours in a style called 'simultaneity'.

P

PAPIER MÂCHÉ (French: 'chewed paper'.) Surface for painting created by soaking paper and then baking it.

PAPIERS COLLÉS (French: 'glued paper'.) Technique which incorporates various kinds of paper into a picture.

PASTICHE Work which uses the style of another artist. A pastiche is not a copy of someone else's work, but a reworking of various techniques and themes into a new composition.

PERFORMANCE ART Art forms characterized by live performance, the presence of an audience, and the involvement of artists who work in various media (e.g. the visual arts, poetry, dance, music, etc.).

PHOTOREALISM (Also called **Hyperrealism** or **Surrealism**.) Style which flourished in the 1970s, based on the production of paintings which look like photographs. Leading figures in this movement are **Chuck Close**, **Malcolm Morley** and **Richard Estes**.

PICTURESQUE 18th-century term used to designate a certain type of landscape, e.g. rolling countryside animated by water and woodland. This type of landscape had a nostalgic element: it celebrated the beauty of the pre-industrial world.

PLASTICITY Characteristic of pictures in which two-dimensional objects give a sense of solidity.

POP ART Movement which emerged in Britain and the US in the 1950s and drew inspiration from aspects of popular culture and consumer-society imagery - e.g. advertising, comic strips, pop music, cinema, etc. It used many techniques: montage, photomontage, collage, assemblage. Elements taken from magazines, posters, food-packaging and cigarette packs were often incorporated into paintings. **Andy Warhol**, **Roy Lichtenstein**, **Tom Wesselman**, **Richard Hamilton**, **R.B. Kitaj**, and **Peter Blake** are amongst the leading exponents of Pop Art.

POSTER ART Art form born in the 19th century, largely as a result of commercialism. **Henri de Toulouse-Lautrec** (1864-1901) produced some of the best-known 19th-century posters. This art has often been used for political purposes throughout the 20th century, and is with us today.

POST-IMPRESSIONISM Term invented by **Roger Fry** in 1910 to describe the work of painters of the generation that came after Impressionism. These painters felt that Impressionism had opened up new approaches to art. But they searched for more 'formal' solutions to painting. Different artists experimented with a wide range of styles and techniques. **Georges Seurat** concentrated on the formal properties of colour by devising the technique known as **Divisionism**. **Paul Gauguin** developed a style that came to be known as **Synthetism**, based on the use of flat areas of colour surrounded by black lines. **Paul Cézanne** pursued the idea of form by creating a technique in which every plane of colour was placed carefully within the overall composition, and colours were chosen to convey a sense of their position in the picture. **Vincent van Gogh** worked with bold streaks of primary colours. His free

brushstroke and audacious use of colour deeply influenced the development of Fauvism.

PRE-RAPHAELITES The Pre-Raphaelite Brotherhood, founded in 1848, was a group of British painters who wished to return to what they saw as the purity of Italian painting before Raphael. Clarity of colour and line were their priorities. The Pre-Raphaelites had a preference for literary, historical and religious themes. Both Classical and medieval traditions were drawn upon. Stylistically, their work was characterized by luminosity, attention to detail and a keenness for decorative patterns, textures and fabrics. The first phase of Pre-Raphaelite art was centred around **Dante Gabriel Rossetti**, **John Everett Millais** and **William Holman Hunt**. In the second phase, the key figures were Rossetti, **Edward Burne-Jones** and **William Morris**. Later painters such as **John William Waterhouse** were deeply inspired by the works of the Pre-Raphaelites, as were Neo-Classical painters (e.g. **Frederic Lord Leighton** and **Lawrence Alma-Tadema**), who continued painting scenes derived from poetry and mythology at the same time as they borrowed themes and ideas from Antiquity.

PROCESS ART Trend popular in the 1960s and 1970s, in which the process of production of a work is still discernible in the final product. All sorts of materials (including grass, fat and coal) were used, and the processes of assembling these materials together were foregrounded. Among the practitioners of process art were **Robert Morris** and **Richard Serra**.

PURISM 20th-century movement devoted to an impersonal and anti-decorative style inspired by mechanical production. Its leading figures were the architect **Le Corbusier** and the painter **Amédée Ozenfant**.

R

RENAISSANCE (French: 'rebirth'.) Revival of Classical art and literature, which started in Italy in the 14th century, to subsequently spread throughout Europe, and reach its peak in the early 16th century. The idea of 'rebirth' was central to the art of this period. Inspired by the rediscovery of the great works of Antiquity, Renaissance artists were devoted to the expression of human rather than divine powers. The prevailing philosophy of the period was indeed termed 'humanism'. This renewed confidence in humanity (by comparison with the Middle Ages) affected deeply the status of the artist, who came to be seen as an individual and inspired creator, rather than a skilled craftsman working in a team. The ideal artist was an eclectic figure, capable of mastering many arts and disciplines. The development of perspective and the systematic study of anatomy enabled Renaissance artists to endow both space and the human body with an unprecedented sense of presence and solidity. The Renaissance is conventionally associated with positive

qualities: optimism, enthusiasm, intellectual curiosity, faith in humanity, an ardent desire to understand and possess the universe in its entirety. But we should not forget that this was also a time of uncertainty and anxiety, where traditional truths were being drastically questioned in all camps: political, religious, and scientific revolutions, as well as the geographical expansion brought about by international trade and colonization, compelled people to reassess radically their sense of space and their place in the world. The main artists associated with the Early Renaissance are **Giotto** and **Masaccio**. The key figures of the High Renaissance are **Raphael, Leonardo** and **Michelangelo**. Northern Renaissance artists include **Albrecht Dürer, Matthias Grünewald, Mabuse** and **Rogier Van der Weyden**.

ROCOCO (French *rocaille*: shellwork and rockwork used to decorate grottoes and fountains.) 18th-century movement which originated in France and subsequently spread throughout Europe. It was characterized by a playful, elegant and highly-decorative style and by a predilection for pastel colours. Rococo was very popular in the sphere of interior decoration. Its leading practitioners in painting were **Jean-Honoré Fragonard, François Boucher, Antoine Watteau, Jacopo Amigoni** and **Giovanni Battista Tiepolo**.

ROMANESQUE Style which emerged in the mid-10th century and lasted until the 12th century, when it was superseded by the Gothic. It took many forms in different parts of Europe, and affected architecture, sculpture, painting, as well as jewellery, metalwork and manuscript illumination. In painting, some of its recurring features were elongated bodies, distorted figures, stylized vegetation, geometric patterns and a strong emphasis on rhythmic movement.

ROMANTICISM Movement which developed in Europe and the US during the late 18th century and the early 19th century. It took many different forms, but was generally characterized by an emphasis on the imagination (as opposed to reason), individual emotions and sensibility, the depiction of intense feelings, a deep attachment to nature, and an interest in the past (especially in its most mysterious and exotic manifestations). Romantic artists include **William Blake, J.M.W. Turner, John Constable, Francisco de Goya, Théodore Géricault** and **Caspar David Friedrich**.

R

SEZESSION (or SECESSION.) Cumulative term for various German and Austrian movements of the 1890s which wished to break away from the restrictive and conservative conventions of academic art. One of the most famous of these movements is the Vienna Sezession, initiated by **Gustav Klimt** in 1897.

SFUMATO (Italian *fumo*: 'smoke'.) Technique which blends colours subtly together to produce a misty effect. It can be employed to suggest a sense of distance in the areas of a landscape farthest away from the picture's foreground.

SOCIAL REALISM Paintings of the life and environment of the lower-middle and working classes in the 20th century. It is usually associated with a group of American painters known as **The Eight**, active after 1900, and a group of English painters known as the **Kitchen Sink** school, active in the 1950s.

SOCIALIST REALISM Official style promoted in the Soviet Union after 1934. It aimed at glorifying labour (both industrial and agricultural) and at idealizing the worker as a hero, through the employment of naturalistic and realistic techniques.

SOFT ART Term introduced in the 1970s to describe sculptural works made from soft materials such as rubber and leather. One of its main practitioners was **Claes Oldenburg**.

STAINED GLASS Technique consisting of staining pieces of glass of various sizes with metal oxides and joining them with leading. Hugely popular in the Gothic era, stained glass was also used in the 19th century by artists such as **William Morris** and **Louis Comfort Tiffany**, and again in the 20th century by **Henri Matisse** and **Marc Chagall**, among others. This technique is used mainly in the production of decorative windows and objects.

SUBLIME Aesthetic feeling which contains elements of bewilderment, danger or terror. The philosopher **Edmund Burke** (1729-97) associated the sublime with nature in its most terrifying and awe-inspiring aspects. Where the beautiful is safely contained within formal boundaries, sublime scenes convey a sense of boundless-ness - incomprehensible greatness, energy or movement. The sublime is closely associated with Romantic art.

SUPREMATISM Abstract style founded by the Russian artist **Kasimir Malevich** in 1913. In a suprematist work, there is no trace of subject matter. The image relies exclusively on the interplay of geometrical shapes and pure colours.

SURREALISM Movement launched in 1924 by **André Breton**'s *Surrealist Manifesto*, and growing partly out of the legacy of Dada. There are two main types of Surrealist pictures: paintings which depict dream-like images by using conventional techniques (**Salvador Dali** and **Giorgio de Chirico** used mainly this approach); and paintings which experiment with innovative techniques (such as **Max Ernst**'s 'frottage'). In all Surrealist art, the worlds of the unconscious and the irrational play a key role. Sexuality, eroticism and the human body are represented in a variety of unconventional ways to overthrow conventional notions of morality and the tyranny of reason. The first type of picture challenges the traditional separation between reality and unreality by presenting scenes which are utterly illogical and populated by uncanny figures, yet rendered with photographic precision. The second type concentrates on specifically technical ways of enabling the unconscious to express itself. Apart from the artists already mentioned, Surrealist practitioners include **René Magritte**, **Joan Miró**, **Yves Tanguy**, **Frida Kahlo** and **R.S.E.Matta**.

SYMBOLISM French movement of the late 19th century, typified by the works of **Odilon Redon** and **Gustave Moreau,** which endowed painting with the power to convey aspects of the inner psyche, rather than the visible surfaces of reality. Sex, death, exotic scenes, monstrous and eerie creatures, mythological motifs, floral decoration and a magical mood were recurring features in Symbolist art. Dreaminess is often inseparable from a nightmarish atmosphere, as though to suggest that the mind harbour simultaneously serenity and dread.

T

TACTILITY Term used in relation to an image whose colours and textures make it look so real that we feel we could touch it.

TROMPE L'OEIL (French: 'deceive the eye'.) Form of illusionism meant to trick the viewer into thinking that a painted surface is a real space.

V

VEDUTA (Italian: 'view'.) Image of a landscape or city, normally characterized by topographical accuracy, in contrast with the *capriccio*, which combines real and fictional elements.

VORTICISM English movement founded by **Wyndham Lewis** in 1914. Its name derives from the idea, put forward by the Italian Futurist **Umberto Boccioni**, that art is produced by an emotional vortex. The movement's main aim was capturing movement in a static image.

Bibliography

Reading Images

Barthes, R.	*Mythologies*, N.Y.: Hill & Wang, 1972
	Image, Music, Text, N.Y.: Hill & Wang, 1977
Baudrillard, J.	*Simulacra and Simulations*, Michigan U.P., 1994
Berger, J.	*Ways of Seeing*, London: Penguin, 1974
Bryson, N.	*Vision and Painting*, London: Macmillan, 1983
Crary, J.	*Techniques of the Observer*, Cambridge: MIT Press, 1990
Foster, H., ed.	*Vision and Visuality*, Washington: Bay Press, 1988
Gombrich, E.	*Art and Illusion*, London: Phaidon, 1990
	The Image and the Eye, London: Phaidon, 1986
	The Story of Art, London: Phaidon, 1989
Gregory, R., ed.	*Oxford Companion to the Mind*, Oxford U.P., 1987
Nochlin, L.	*Realism*, Harmondsworth: Penguin, 1971

What is Art? & Art as Document

Butler, A. et al.	*The Art Book*, London: Phaidon, 1996
Freedberg, D.	*The Power of Images*, Chicago U.P., 1989
Gates, H.L., ed.	*'Race', Writing, and Difference*, Chicago U.P., 1986
Gidley, M.	*Representing Others*, Exeter, 1990
Gregory, C.A.	*Gifts and Commodities*, London: Academic Press, 1982
Harrison, C., ed.	*Art in Theory*, Oxford: Blackwell, 1992
Impey, O., ed.	*The Origins of Museums*, Oxford U.P., 1985
Mitchell, W.	*Iconology*, Chicago U.P., 1986
Nelson, R.S., ed.	*Critical Terms for Art History*, Chicago U.P., 1996
Panofsky, E.	*Meaning in the Visual Arts*, London: Penguin, 1970
Preziosi, D.	*Rethinking Art History*, Yale U.P., 1989
Read, H.	*The Meaning of Art*, London: Faber & Faber, 1980
Rubin, W., ed.	*Primitivism*, N.Y.: Museum of Modern Art, 1984
Said, E.	*Orientalism*, N.Y.: Random House, 1978
Schama, S.	*The Embarrassment of Riches*, California U.P., 1988
Torgovnick, M.	*Gone Primitive*, Chicago U.P., 1990
Triado, J.	*The Key to Painting*, Tunbridge Wells: Search, 1993
West, S., ed.	*Guide to Art*, London: Bloomsbury, 1996
Wollheim, R.	*Painting as an Art*, Princeton U.P., 1987

The Concept of the Artist

Broude, N., ed.	*Feminism and Art History*, N.Y.: Harper & Row, 1982
Chadwick, W.	*Women, Art, and Society*, London: Thames & Hudson, 1993

Cherry, D.	*Painting Women*, London, 1993
Crow, T.E.	*Painters and Public Life*, New Haven & London, 1985
Duro, P.	*The Academy and the Limits of Painting*, N.Y., 1996
Hadjinicolaou, N.	*Art History and Class Struggle*, London: Pluto, 1973
Haskell, F.	*Patrons and Painters*, London, 1963
Moran, B., ed.	*Patronage and Institutions*, Woodbridge, 1991
Pevsner, N.	*Academies of Art, Past and Present*, N.Y., 1973
Pollock, G.	*Vision and Difference*, London: Routledge, 1988
Rosaldo, M., ed.	*Woman, Culture, and Society*, Stanford U.P., 1974
Sulter, M., ed.	*Passion: Black Women's Creativity*, Hebden Bridge,1990
Trevor Roper, H.	*Princes and Artists*, N.Y., 1976
Wolff, J.	*The Social Reproduction of Art*, London, 1982

Aesthetics

Bhabha, H.	*The Location of Culture*, N.Y.: Routledge, 1994
Benhabib, S.	*Situating the Self*, N.Y.: Routledge, 1992
Bloch, E. et al.	*Aesthetics and Politics*, London: NLB, 1977
Burger, P.	*Theory of the Avant-Garde*, Minnesota U.P., 1984
Calinescu, M.	*Five Faces of Modernity*, Durham, N.C.: Duke U.P., 1987
Collingwood, R.G.	*The Principles of Art*, Oxford U.P., 1938
Duncan, C.	*The Aesthetics of Power*, Cambridge U.P., 1993
Eagleton, T.	*The Ideology of the Aesthetic*, Oxford: Blackwell, 1990
Foster, H., ed.	*The Anti-Aesthetic*, Washington: Bay Press, 1983
Fry, R.	*Vision and Design*, Oxford U.P., 1981
Grace, H., ed.	*Aesthesia & the Economy of the Senses*, Sydney, 1996
Greenberg, C.	*Collected Essays*, Chicago U.P., 1986
Habermas, J.	*The Philosophical Discourse of Modernity*, MIT, 1987
Hauser, A.	*The Philosophy of Art History*, Cleveland: World, 1963
Hegel, G.W.F.	*Aesthetics*, Oxford: Clarendon, 1975
Jameson, F.	*The Political Unconscious*, Cornell U.P., 1981
Jencks, C., ed.	*The Postmodern Reader*, London, 1992
Kant, I.	*Critique of Judgment*, Indianapolis: Hackett, 1987
Lyotard, J.-F.	*The Postmodern Condition*, Manchester U.P., 1984
Regan, S., ed.	*The Politics of Pleasure*, Open U.P., 1992
Sheppard, A.	*Aesthetics*, Oxford U.P., 1987
Wallis, B. ,ed.	*Art after Modernism*, N.Y.: New Museum, 1984

Semiotics

Derrida, J.	*Writing and Difference*, Chicago U.P., 1978
Eco, U.	*A Theory of Semiotics*, Indiana U.P., 1976
Genette, G.	*Narrative Discourse*, Cornell U.P., 1980
Greimas, A.J.	*Semiotics and Language*, Indiana U.P., 1983
O'Toole, M.	*The Language of Displayed Art*, Leicester U.P., 1994
Peirce, C.S.	*Peirce on Signs*, North Carolina U.P., 1991

| Saussure, F. de | *Course in General Linguistics*, N.Y.: Doubleday, 1966 |
| Todorov, T. | *Theories of the Symbol*, Oxford: Blackwell, 1982 |

Space and Perspective

Bell, A.C.	*Art*, Oxford U.P., 1914
Berger, J.	*Ways of Seeing*, London: Penguin, 1974
Bryson, N.	*Vision and Painting*, London: Macmillan, 1983
Gombrich, E.	*Art and Illusion*, London: Phaidon, 1990
	The Image and the Eye, London: Phaidon, 1986
Greenberg, C.	*Collected Essays*, Chicago U.P., 1986
Lash, S.	*Economies of Signs and Space*, London: Sage, 1994
Wolfflin, H.	*Principles of Art History*, N.Y.: Dover, 1950

Materials and Techniques & Genres

Adler, K., ed.	*The Body Imaged*, Cambridge U.P., 1993
Barrell, J.	*The Dark Side of the Landscape*, Cambridge U.P., 1980
Berger, J.	*Ways of Seeing*, London: Penguin, 1974
Bryson, N.	*Vision and Painting*, London: Macmillan, 1983
Bermingham, A.	*Landscape and Ideology*, California U.P., 1986
Bohm-Duchen, M.	*The Nude*, London: Scala, 1992
Brilliant, R.	*Modern Art*, London: Thames & Hudson, 1990
Clark, K.	*The Nude*, London: Penguin, 1960
Copley, S., ed.	*The Politics of the Picturesque*, Cambridge U.P., 1994
Daniels, S.	*Field of Vision*, Cambridge U.P., 1993
Fontana, D.	*The Secret Language of Symbols*, London: Pavilion, 1993
Gent, L., ed.	*Renaissance Bodies*, London: Reaktion, 1990
Gombrich, E.	*Symbolic Images*, London: Phaidon, 1972
Goodman, N.	*The Languages of Art*, Indianapolis: Hackett, 1976
Levey, M.	*From Giotto to Cézanne*, London: Thames & Hudson, 1993
Lucie-Smith, E.	*Symbolist Art*, London: Thames & Hudson, 1993
	Movements Since 1945, London: Thames & Hudson, 1993
McQuillan, M.	*Impressionist Portraits*, London, 1986
Mitchell, W., ed.	*Landscape and Power*, Chicago U.P., 1994
Nead, L.	*The Female Nude*, London: Routledge, 1992
Pointon, M.	*Naked Authority*, Cambridge U.P., 1990
	Hanging the Head, New Haven & London, 1993
Pope-Hennessy, J.	*The Portrait in the Renaissance*, Princeton U.P., 1966
Schneider, N.	*The Art of the Portrait*, Cologne, 1994
Stangos, N., ed.	*Concepts of Modern Art*, London: Thames & Hudson, 1993
Strong, R.	*Gloriana*, London: Thames & Hudson, 1987
Triado, J.	*The Key to Painting*, Tunbridge Wells: Search, 1993
Warner, M.	*The Inner Eye*, National Touring Exhibitions, 1996
Whitford, F.	*Expressionist Portraits*, London, 1987

Consuming Art

Appadurai, A.	*The Social Life of Things*, Cambridge U.P., 1986
Benjamin, W.	*Illuminations*, N.Y.: Harcourt, Brace & World, 1968
Finn, D.	*How to Visit a Museum*, New York: Abrams, 1985
Pearce, S., ed.	*Art in Museums*, London, 1995
Vergo, P.	*The New Museology*, London, 1989

Index

C

D

Gropius, Walter 54, 157
Grosz, George 119
grotesque 162

Grünewald, Mathis 168
guild 45-46

hallucination 15
Hamilton, Richard 166
happening 162
Hartung, Hans 156
Hausmann, Raoul 159
Heckel, Erich 160
Hegel, Georg Wilhelm Friedrich 73-74, 133
Hellenism 146
heraldry 138

history painting 140, 155
Hobbes, Thomas 69
Hofmann, Hans 155
Holbein, Hans 155
Holt, Nancy 160
homo faber 43
Huebler, Douglas 158
Hunt, William Holman 167
Huysmans 159
hyperrealism see 'photorealism'

iconology 162
ideology 3, 5, 24, 52, 64-65, 70, 89, 113, 117, 147-48
illusion 8-15, 114
illumination (light) 66, 139, 141
illumination (text) 162
image
- as body 21-24, 124-26
- as commodity 152-54
- as construct 1-5
- as displayed object 28
- as expression 19
- as illusion 8-15
- as perception 88-90

- as sign 94-105
- as text 6
imagination 23, 66-74
imagism 78
imitation 22, 67
Impression: Sunrise (Monet) 162
Impressionism 78, 136, 162
Ingres, Dominique 132, 145
installation 162
interpretant 96-97
interpretation 92-93, 94-105
intertextuality 84
invisibility 5
Italy 47

Jawlensky, Alexei von 160
journeyman 45
Judd, Donald 164

Jugendstil 156
Junk Art 163

Kafka, Franz 82
Kahlo, Frida 145, 169

Kandinsky, Wassily 120, 124, 134, 138, 140

L

M

N

O

P

R

S

The Authors

Dani Cavallaro's main research interests are literature, the visual arts, philosophy, popular culture, fashion, critical theory and psychoanalysis. Her publications to date include: *The Body for Beginners, Fashioning the Frame: Boundaries, Dress and the Body* (co-authored with Alex Warwick), contributions to a volume on *Art and Society* and to a *Companion to the Twentieth-Century Novel*. Her forthcoming books and essays include: *Cyberpunk and Cyberculture: Science Fiction and the Work of William Gibson, Kristeva For Beginners, Feminism For Beginners*, and contributions to a collection of essays on Italo Calvino and to a book on Samuel Beckett and philosophy (of which she is also co-editor).

Carline Vago-Hughes is a visual craftsman who specialises in covering a wide range of art and design in many varied dimensions creating images for Conde Nast, Time Life Books, EuroDisney and Bloomberg Financial News amongst others. She also illustrated *The Body For Beginners*.

Inspiration for illustrations

Page 1: Cave Art, Altamira, Spain c.13,000BC.
 Pablo Picasso, *Bulls*, c.1950
Page 2: Edouard Manet, *A Bar at the Folies-Bergères*, 1881-82
Page 3: Odilon Redon, *A Cyclops*, 1898-1900
Page 4: Lambert Maria Wintersberger, *Sodom and Gomorra*, 1969
Page 5: George Frederick Watts, *Hope*, 1886
Page 6: Kurt Schwitters, *Merzpicture/The Star Picture*, 1920
Page 7: Andy Warhol, *4 Mona Lisas*, 1963
Page 8: René Magritte, *Personal Values*, 1952
Page 12: Diego Velazquez, *Venus with a Mirror*, 1649-51
Page 16: Marcel Duchamp, *Bicycle Wheel*, 1913
Page 17: Michelangelo, *The Creation of Adam*, 1508-12
Page 22: Peter Paul Rubens, *The rape of the daughters of Leucippus*, c.1618
 Marcel Duchamp, *Fountain*, 1917
Page 25: Toto Nac, *Anthropomorphic Sculpture Representing Duality*, 900-1521
Page 26: Paul Gauguin, *Where Do We Come From?*, 1897
 Pablo Picasso, *The Muse*, 1935
Page 28: Francis Bacon, *Studies for Figures at the Base of a Crucifixion*, 1944
Page 30: T. Jones Barker, *Queen Victoria (presenting a Bible in the Audience Chamber at Windsor)*, c.1861
 Bruno Braquehais, *Nude*, 1855-57
Page 31: Gustav Klimt, *Danae*, 1907-08
 Henri Matisse, *Green Stripe (Madame Matisse)*, 1905

ARTAUD FOR BEGINNERS™
Gabriela Stoppelman
Illustrated by
Jorge Hardmeier
ISBN 0-86316-291-6

US $11.95
UK £7.99

Artaud for Beginners™ reveals the life and art of the man known in the avant-garde world as a "totally rebellious artist." His book, *The Theater and Its Double*, was first published in 1938, and is still considered one of the most important contributions to 20th century theater. Leading figures in the theater have attempted to turn into practice some aspects of Artaud's theory on drama, such as his "cruelty theory."

Artaud's "cruelty" aspires to a type of theater where the language of physical movement and gesture could be applied on a multitude of psychological levels. Artaud's intention was to abolish the boundaries between life and art. He applies this criterion to all his artistic productions, including: poetry, cinema, drawing and painting.

It is impossible to classify his books by specific genres, because he broke all genre rules. From his poems, *The Umbilicus of Limbo* and *The Nerve Meter*, to his most mature works such as *Van Gogh: The Man Suicided by Society*, Artaud rejected the acceptable and palatable conventions of traditional theater that serve to limit or mask the real torment of human suffering.

Artaud had suffered from illness since he was a small boy; later in life he endured drug addiction, rehabilitation treatments, nine years confinement in a series of psychiatric hospitals, and electroshock therapy. None of the horror that Artaud experienced in his life prevented him from gaining international recognition for his contribution to the art and theater worlds.

CASTANEDA FOR BEGINNERS™
Martin Broussalis
Illustrated by
Martin Arvallo
ISBN 0-86316-068-9

US $11.95
UK £7.99

In the summer of 1960, Carlos Castaneda was a student of Latin-American anthropology, based in California. Academic logical reasoning had become ingrained in him. He met with the sorcerer Don Juan Matus, whose knowledge of the Toltec tradition went back thousands of years. Don Juan initiated Castaneda through a lengthy apprenticeship, which was by no means easy. During that time he saw all his convictions falling away, transforming himself despite himself, by entering into the magical universe pointed out to him by the sorcerer.

Following the teachings passed on to him by Don Juan, Castaneda wrote a string of books describing his initiation, the other worlds discovered through new ways of seeing, and his experiences with the group of apprentices and sorcerers.

In **Castenada for Beginners**™, the Argentinean novelist Martin Broussalis follows the path of Castaneda through these new dimensions of knowledge, arriving at the present time and Castanededa's position of shaman, transmitting under the name of Tensegrity his range of energising exercises.

**BUKOWSKI
FOR BEGINNERS®**
Carlos Polimeni
ıstrated by Miguel Rep
ISBN 0-86316-285-1

US $11.95
UK £7.99

Bukowski for Beginners® examines the life and literary achievements of this unique American writer. Charles Bukowski is a cult figure of the dissident and rebellious, novelist, short story writer, poet and journalist.

Bukowski was born in Germany in 1920 and died in the United States in 1994. He was one of the most unconventional writers and cultural critics of the 20th century. Bukowski lived his life in his own way and wrote in a style that was impossible to classify or categorize. His work is cynical at times and humorous at others, but always brilliant, and always challenging. His life and work is distinguished not only by this remarkable talent for words, but also his rejection of the dominate social and cultural values of American Society—the American Dream.

Bukowski began writing at the age of 40, and during that time he published 45 books, six of them novels. Along with Raymond Chandler and Joan Didion, he is a great voice of Los Angeles and Southern California; an area full of contradictions and chimeras hidden beneath the masquerade of wealth and progress.

**KEROUAC
FOR BEGINNERS™**
Miguel Grinberg
Illustrated by
Frederico Stuart and
Theo Lafleur
ISBN 0-86316-287-8

US $11.95
UK £7.99

Jack Kerouac (1922-1969) is not only one of the major writers of the United States after World War II, but also the best known figure of the Beat Generation. "The Beats" were portrayed by Kerouac in his best selling novel *On the Road* as aesthetic pilgrims—pilgrims who were "mad to live, mad to talk, mad to be saved." Kerouac and his contemporaries used this madness to test the boundaries of everything: frenetic sex, writing, living, Zen Buddhism, fast cars, freight trains and be-bop Jazz.

Kerouac for Beginners™ is a journey into the world of Kerouac's major novels and poems. Kerouac is accompanied on his short, but fast paced journey by other visionaries like Allen Ginsburg and William S. Burroughs. Through their literary and lifestyle experimentation, Kerouac and his fellow Beats laid down the foundation for the more wide spread cultural revolution of the hippies in the 1960s.

How to get original thinkers to come to your home...

Individual Orders

US
Writers and Readers Publishing, Inc.
P.O. Box 461, Village Station
New York, NY 10013
Phone: 212.941.0202
Fax: 212.941.0011
sales@forbeginners.com
www.writersandreaders.com

UK
Writers and Readers Ltd.
2a Britannia Row
London N1 8QH
Phone: 171.2711.837.0643
Fax: 171.2711.837.0645
begin@writersandreaders.com
www.writersandreaders.com

Trade Orders

US
Publishers Group West
1700 Fourth St.
Berkeley, CA 94710
Phone: 800.788.3123
Fax: 510.528.9555

Canada
Publishers Group West
250 A Carlton St.
Toronto, Ontario
M5A2LI
Phone: 800.747.8147

UK
Littlehampton Book Services Ltd.
10-14 Eldon Way
Littlehampton
West Sussex BN77HE
Phone: 1903.828800
Fax: 1903.828802
orders@lbsltd.co.uk

South Africa
Real Books
5 Mortlake St.
Brixton, 2092
Phone: 2711.837.0643
Fax: 2711.837.0645

Australia
Tower Books
Unit 9/19 Rodborough Rd.
French Forest NSW 2086
Phone: 02.9975.5566
Fax: 02.9975.5599

SHIP TO (NAME)

ADDRESS

CITY STATE ZIP

COUNTRY

TELEPHONE (DAY) (EVENING)

To request a free catalog, check here: ☐

Title	Quantity	Amount

SUBTOTAL

New York City residents add 8.25% sales tax

Shipping & Handling: Add $3.50 for 1st book,
$.60 for each additional book

TOTAL PAYMENT